NEW TECHNIQUES IN EGG TEMPERA

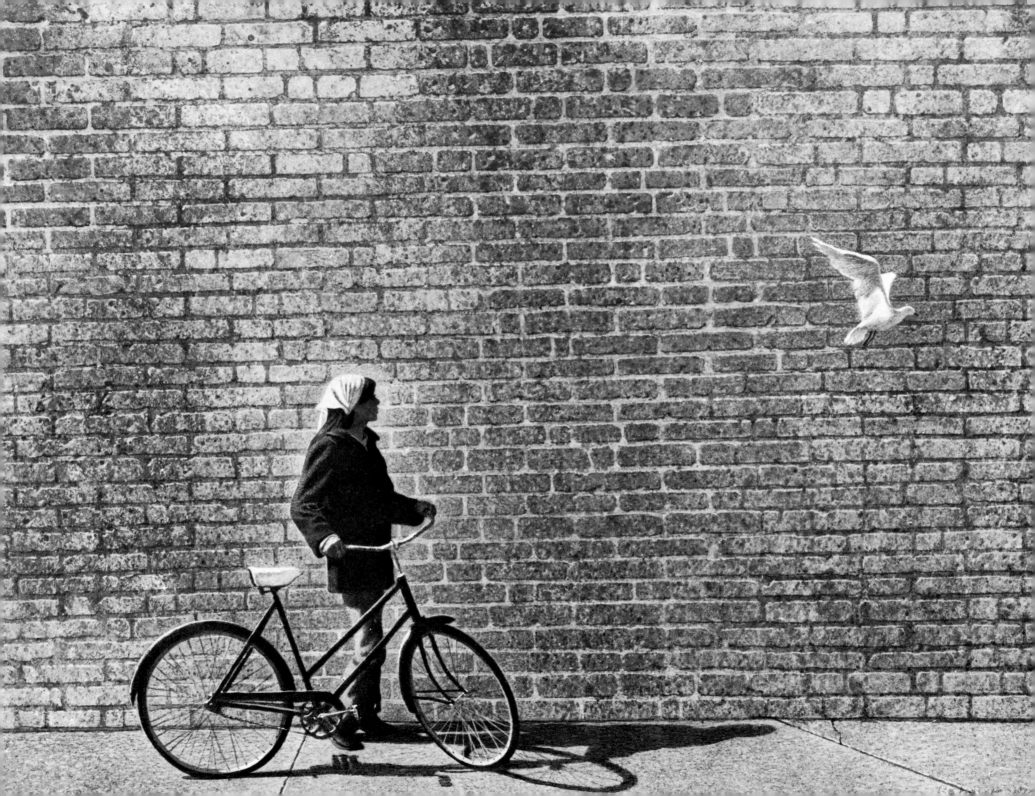

NEW TECHNIQUES IN EGG TEMPERA

BY

ROBERT VICKREY

AND DIANE COCHRANE

The Pigeon, 12" x 16". I dripped paint on the wall in this painting to create little holes or pits in the brick. To emphasize their depth I put highlights under them. Collection, Mr. Arthur Lewis.

WATSON-GUPTILL PUBLICATIONS, NEW YORK

First published 1973 in the United States and Canada by Watson-Guptill Publications,
a division of Billboard Publications, Inc.,
1515 Broadway, New York, N.Y. 10036

Library of Congress Cataloging in Publication Data
Vickrey Robert, 1926—
 New techniques in egg tempera.
 1. Tempera painting. I. Cochrane, Diane,
joint author. II. Title.
ND2468.V52 751.4′3 73-7760
ISBN 0-8230-3170-5

Manufactured in Japan.

First Printing, 1973
4 5 6 7 8 9/86 85 84 83 82

Acknowledgments

I am most grateful to the following people for their invaluable help. To my sons, Scott Vickrey and Sean Vickrey, for their photography; to Sarah Gorman and Otto Nelson, photographers; to William Steadman, Director of the Museum of Fine Arts, University of Arizona; and especially to the Midtown Galleries, New York City, and Mrs. Adele Gruskin for their continuing cooperation.

Contents

Bell Chain, 20″ x 30″. The decaying wall perhaps represents the corruption that surrounds even the spiritually pure. Collection, Mr. and Mrs. John Lott.

Introduction

Beauty and elegance sum up Robert Vickrey's work. Jewellike textures and shimmering light create the beauty; extraordinary—and sometimes extraordinarily complicated—designs produce the elegance. Both are a product of superb skill.

And phenomenal skill is what Vickrey has. It's no coincidence that he can produce spectacular light and textural effects that not only enhance his brilliant compositions but make integral contributions to them. It's no accident that he can use unconventional techniques, such as splattering, and transform them into highly realistic, highly organized designs. It's no exaggeration when John Canaday of *The New York Times* calls Vickrey "the world's most proficient craftsman in egg tempera painting." And such craftsmanship takes patience, talent, and technical wizardry—qualities largely ignored for the past three decades.

When Robert Vickrey began to paint, back in the forties, abstract expressionism was making its debut on the American scene. And as its popularity grew through the next two decades and its forms became more extreme, many painters adopted the chance techniques involved in this style and its vigorous offshoots. Like action painting, for example: paint was thrown, sprayed, dripped, splattered, smeared by naked bodies, and left untouched by refinements. Almost anything was accepted. During the heyday of abstraction many arbiters of taste judged works of art not on skill, but on mindless spontaneity.

Vickrey, however, never deviated from his course, never toed the fashionable line of the avant-garde. And his convictions have been justified: technical genius has been restored to its proper place in pictorial art. Critics and painters alike have renounced their passion for chance techniques as the only way to paint, just as they have admitted that representational art is as valid and vital as abstract art.

Under the Swings, 24" x 36". There is a strong narrative element in many of my paintings. This one, for example, conveys the idea that horror exists alongside joy even in the innocent world of children. Collection, Dr. John M. Shuey.

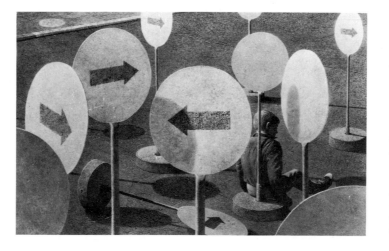

Signs, 24" x 36". The Kafkaesque atmosphere of contemporary civilization is symbolized by the outsized signs. A child sits under one of them unable to decide which way to go. Collection, Corcoran Gallery, Washington, D.C.

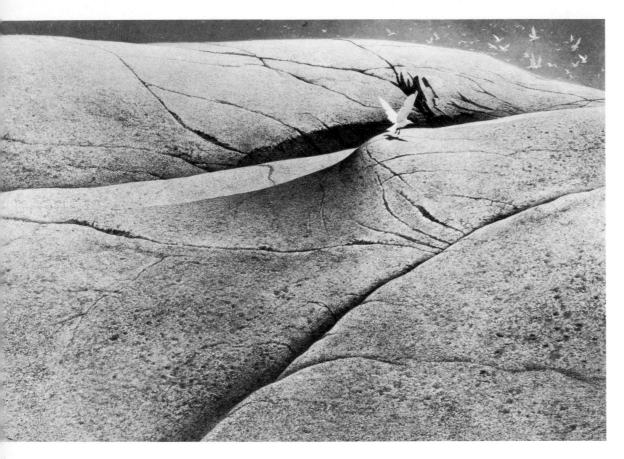

Gull Rock, 24″ x 36″. *I planned this painting so the form of the bird would be echoed throughout the rock by cracks and crevices. A head looms up here, a wing there. Courtesy, Midtown Galleries.*

Remnants (Opposite page), 29″ x 36″. *A discarded heap of my daughter's dolls caught my eye one day and I decided to paint it. In transferring the image from my eye to a panel, the nostalgic scene became more sinister. Collection, Mr. Barnett Owen.*

But this shift in esthetic emphasis means little to Vickrey. Despite his decision to remain outside what seemed the mainstream of American art for several decades, success came quickly. Within a year after he began to paint full-time, he found a gallery to show his work. His first one-man show was almost completely sold out. The first painting he submitted to the Whitney Museum's annual show was accepted. An editor at *Time* saw his work at the museum and asked him to do a cover for the magazine. This cover led to some ninety others, including portraits of Lyndon Johnson, Robert McNamara, and Martin Luther King.

Museums have also joined the Vickrey bandwagon. The Metropolitan Museum of Art, the Whitney Museum of American Art, the New York Cultural Center, the Corcoran Gallery of Art, and more than thirty-five others now own his work. Private collectors have sought his paintings as well, and he's represented in some of the best collections in America.

Brilliance of design and mastery of the egg tempera medium, which allows him to capitalize on special effects, explain Vickrey's success. On a less obvious level, the narrative value of his work also enhances his reputation.

Vickrey chooses the subjects of his paintings for their intrinsic interest; they excite him visually. But unconsciously he also uses them to reveal how he thinks about life. In his view, ours is not the best of all possible worlds. And this comes across in his work. Nuns portrayed against decaying backgrounds suggest that spiritual purity is almost an anachronism in a materialistic world. Outsized traffic indicators *(Signs)* represent the overwhelming mechanical forces that dominate our lives. Children fantasize that they can escape to a happier world in their gliders.

At times Vickrey's vision darkens further. The world, even the world of innocent children, he says, is full of danger. In *Under the Swings,* the joyful swinger is about to be impaled on deadly looking spikes, while the bony claws of the shadows reach out to ensnare him.

The menace deepens in *The Monument,* one of Vickrey's most important paintings. The idea for the work came from two sources. An uninteresting statue of a South American

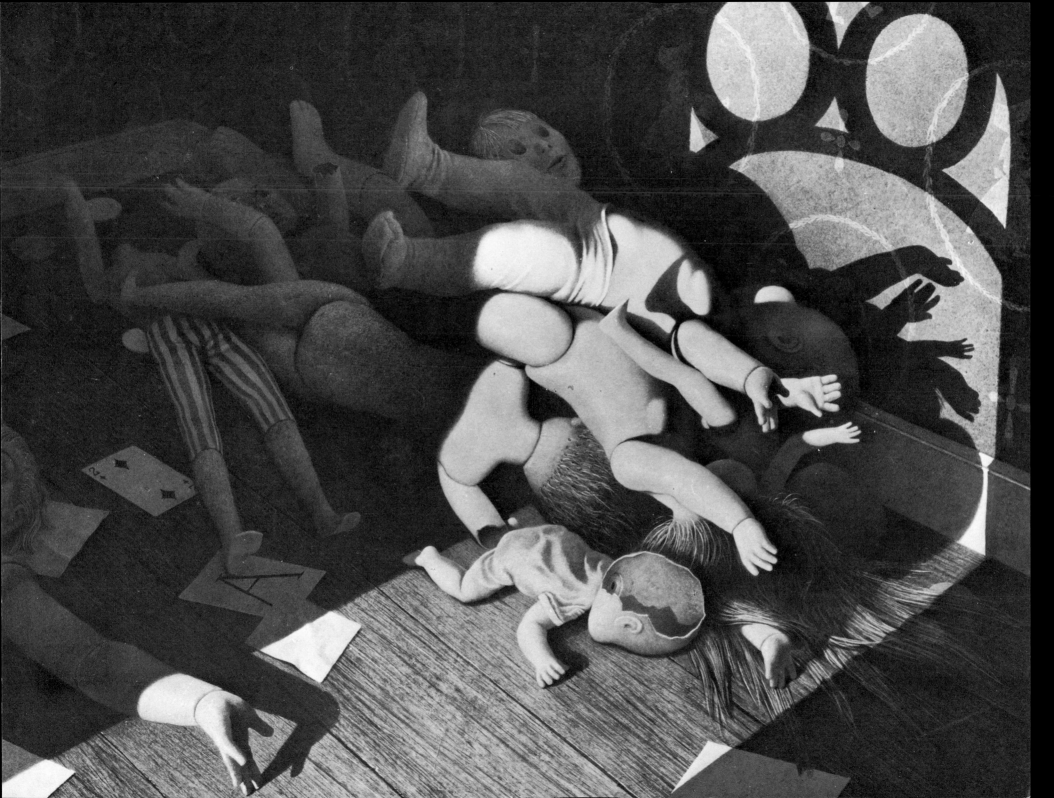

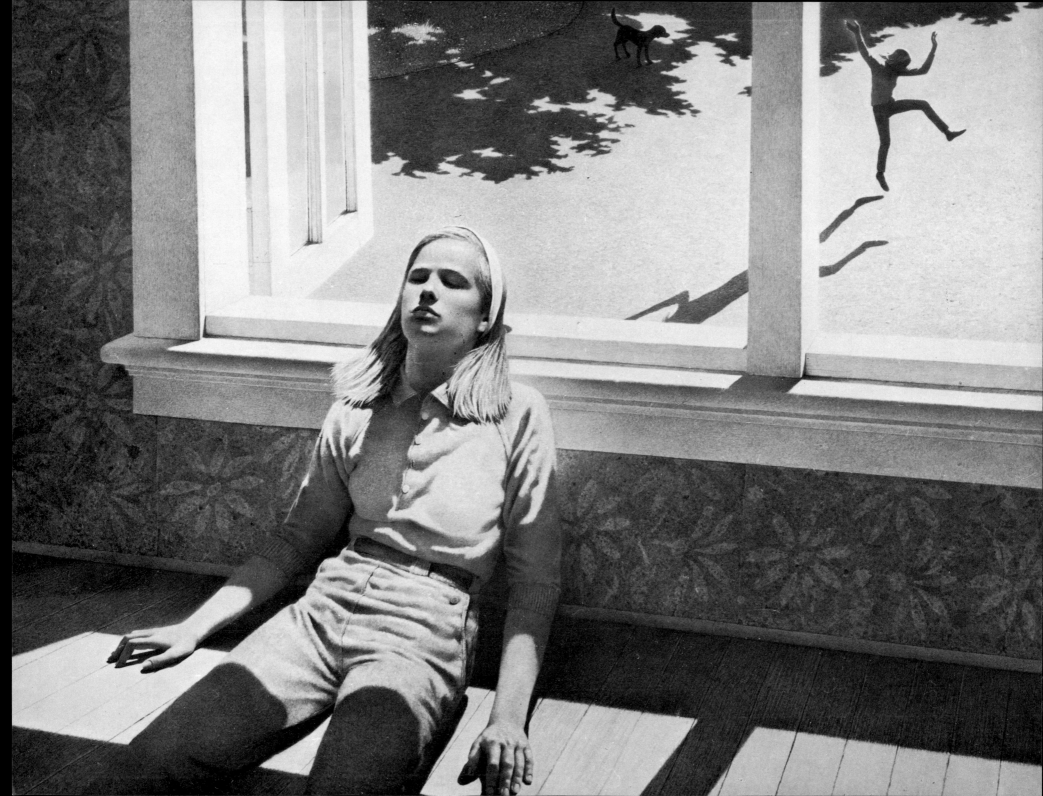

leader in New York's Central Park was wrapped in tarpaulins at the request of the country's United Nations delegation for political reasons. Vickrey found this accidental work of art far more impressive than the original statue; far more original than the work of artists who find a creative outlet in covering, say, Australian cliffs with sheets of plastic. The absurd figure sparked his imagination and he decided to paint it. As he worked, the head of the horse began to look like a monstrous tiger and its attitude became threatening. Sometime later he was asked to cover a moon shot at Cape Kennedy. Around the launching pad stood dozens of cameras. Since they were kept there permanently, they were covered with canvas when not in use. These hooded cameras reminded Vickrey of an assembly of Ku Klux Klanners, and he added these sinister forces to the painting.

Vickrey painted *The Monument* during the height of the Vietnam War, and it expresses his feelings at that time. The statue, once a symbol of nobility and honor, has been transformed into a corrupt beast of war. The hooded figures stand for the muffled voices of the news media. The superficially gay flowers (a favorite Vickrey motif) represent those cheerful war reports—they try to gloss over the threatening ambiance, but they can't hide the ugliness any more than false words can conceal a shameful war.

If menace is never far away in these paintings, it nearly explodes into its full horror in *Remnants*. On the surface the painting seems a familiar scene. Discarded dolls, broken and worn out with use, are heaped in the corner of a little girl's room, papered with Victorian maidens and Peter Rabbits. A rather nostalgic picture, at first glance. But look again. Are those dolls or bodies? Their shadows are lifelike. The faces of the two upturned dolls are frozen with terror. The striped pants recall prisoners' pajamas. The light area resembles the mouth of an oven. The shadows of the windowpane evoke the image of the god Moloch, who (in the Bible) demanded the sacrifice of children. As Vickrey points out, this is no cozy bedroom; this is Buchenwald.

Vickrey doesn't always see through the glass so darkly. Many of his paintings explore the fanciful possibilities of the real and unreal. Is the dancing child in *Dream Dance* his daughter imprisoned in the body of the serious-looking sleeping girl? Is the little girl in *Fish Ride* landlocked on a city street, or riding waves in exhilarating freedom? Is the rock in *Gull Rock* merely a relic of the ice age or the head of a soaring bird?

If Vickrey's paintings sometimes pose questions of reality, so does the egg tempera technique he works with. And this concerns him. He feels that a great deal that has been taught and published about egg tempera has been fiction, not fact, and he wants to set the record straight on the real capabilities of the medium. So he agreed to do a series of taped interviews on the subject. The first-person account that follows is the result of these sessions. The thoughts are his; only the syntax has changed.

Diane Cochrane

Dream Dance, 30" x 40". This is my daughter Nicole dreaming she is the dancing girl outside the window. I wonder which is a more exact portrait, the serious girl or the shadow leaping for joy? Collection, Mr. and Mrs. Robert Steinberg.

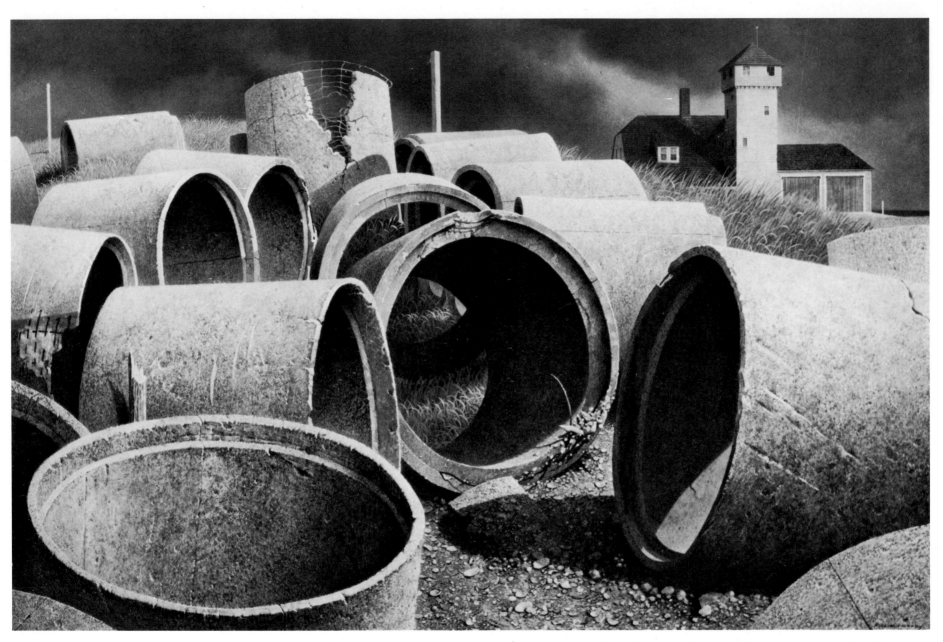

Coast Guard Station, 24″ x 36″. Some people may not find much beauty in old pipes. But when I came across a pile of them one day, I was struck by their abstract rhythms and their textures. Collection, Mr. Bourke Gill Spellacy.

1. Why I Paint in Egg Tempera

When I first began to think about this book, I felt that the title should be *Everything You Always Wanted to Know about Egg Tempera . . . but Were Afraid to Ask*. My publishers disagreed. "Lacks dignity," they complained. I bowed to their judgment, but I think they missed the point.

Egg tempera is a simple, cheap, easy-to-use technique that produces gorgeous effects—sounds terrific, doesn't it? Yet nobody seems to know it. Its real possibilities have been obscured by stuffy, up-tight academicians who have filled the literature with strict proscriptions on what you can and can't do with the medium. So I thought a slightly sensational title might stir up interest in this much-maligned method, and a practical, down-to-earth text might blow away the cobwebs that cling to it.

Egg Tempera

But first I should offer a brief explanation of what egg tempera is. Paint for egg tempera consists of dry pigments, water, and egg (usually the yolk). The combination of these particular ingredients produces paint with three important characteristics. First, it forms an insoluble film that can be overpainted either with more tempera, or a coat of oil paint. Second, it dries to the touch in seconds (although it takes a year or more to dry chemically) and more paint can be applied within minutes. Third, it adheres to the panel with extraordinary tenacity, but only if the paint is applied thinly (thick layers will crack and fall off) and built up in thin layers. It's this layering process that makes egg tempera so unique. Each coat of underpainting glows through the subsequent overpainting, even when the final coats are fairly opaque. The optical result is a luminosity which can't be duplicated by other mediums.

Now, when most painters think about egg tempera—if they think about it at all—they associate the term with an ancient technique so tedious and complicated that only some sort of compulsive neurotic would attempt it. And quite rightly. Egg tempera, as used by medieval and early Renaissance painters such as Fra Angelico, Verrocchio, Duccio, and Botticelli, was a painstaking process—so painstaking, in fact, that when a more flexible medium, oil, was developed,

Figure 1. *Crosshatching is the traditional method of modeling and is still used by egg tempera painters who don't glaze and scumble.*

Under the Skylight (Left), 20″ x 30″. Egg tempera is great for textures such as fur and hair because strokes dry quickly and stand out. Strokes brushed on with oil paint tend to be fuzzy, an advantage when you want to blend. Collection, Mr. and Mrs. Norton S. Walbridge.

Fear (Above Right), 34″ x 58″. Some artists today feel they must express their contempt of society by painting harsh, ugly, photographic paintings. I don't think a painting need be ugly to express a strong indictment. In this painting, for example, the shimmering effects produced by egg tempera strengthen, rather than detract from, the image of a nun fleeing the rubble and erosion of contemporary civilization. Collection, Sara Roby Foundation, New York.

Through the Window (Right), 20″ x 30″. Notice the tiny specks of dust in the light coming through the window. They were created by pulling my finger across a toothbrush loaded with paint. Collection, Mrs. J. Frank Forster.

The Apple Eater, 24" x 36". *Here is another texture I love to paint: a crumbling old wall. I posed my son Sean in a house we had moved out of, but not sold, and exaggerated the defects in the walls. Collection, Mr. J. L. Steenhuis, Jr.*

Cobblestone Street (Opposite Page), 24" x 18". *The mood here is almost reminiscent of de Chirico: the shadow is ominous; the street, surrealistic. One of the beauties about cobblestone streets is that often when they are repaired, the stones are laid in a different direction, creating an abstract design. Private collection.*

most artists quickly changed their alliance. By the end of the fifteenth century, egg tempera was technologically obsolete and forgotten by all except as underpainting. You can see just how abrupt the change was by looking at Verrocchio's well-known *Baptism of Christ, with Two Angels.* Most of the work was done in egg tempera except for one of the angels. This angel, reportedly done by Verrocchio's student, Leonardo da Vinci, was obviously painted in oil.

Egg tempera remained a lost art until 1844 when an Englishwoman, a Mrs. Merrifield, translated a book by Cennino Cennini, a fifteenth-century Italian. Cennini had written the definitive explanation of how the old masters used egg tempera, and the translation created renewed interest in the medium, although it wasn't really revived until the 1920's and 1930's. So before we go any further, let's take a look at this book. Why? Because painters today are still influenced by Cennini's ideas even though the treatise is over 500 years old.

Egg Tempera and the Old Masters

Cennini wrote *Trattato della Pittura* about the techniques used by followers of Giotto, the great Florentine painter who singlehandedly changed the course of art history. Painting before Giotto was influenced by Byzantine art with its emphasis on linear rhythms and decorative massings of sumptuous flat color. Giotto revolutionized art by setting his sights on a naturalism based on perspective—a naturalism that burst into full bloom at the height of the Renaissance. His immediate disciples, however, vacillated between pallid imitation of his method and the traditional medieval style, with the latter usually winning. So naturalism, which emphasized forms and figures placed in deep space and natural light, took a back seat in Cennini's book. He stressed instead the techniques used by medievalists who constructed form out of purely formal elements—line, light and dark, and flat color.

With this background in mind, I want to explain how Cennini would have advised you to paint a portrait in egg tempera. Naturally, this description has been updated—Cennini probably didn't use the same method for transferring

drawings as we do, for example—but it will give you an approximate idea of the process and an understanding of why his techniques made sense.

Step 1. Draw your figure lightly in pencil on toned paper. Crosshatch dark tones in black ink and light areas with white watercolor. When the drawing is complete, so too is the creative process. You'll make no corrections; attempt no improvements. The preliminary composition is the final composition. Why? This was the way medieval and early Renaissance artists coped with the quick-drying quality of egg tempera. They reasoned that if you knew what you were doing every step of the way, you'd never make a mistake.

Step 2. Place tracing paper over the original drawing and trace the outlines of the elements in pencil.

Step 3. Prepare homemade carbon paper by covering the surface of a second piece of tracing paper with the scribbling of a soft pencil. Place this between a gesso panel and the first tracing paper and redraw the lines, thus transferring the drawing onto the panel. Centuries ago artists had their students transfer their drawings—an understandable delegation of duties.

Step 4. Refine the drawing by meticulously repeating those tedious India ink crosshatches. This is your underpainting. At this point you have drawn three versions of your original design and are just starting to paint. Better late than never, I suppose, but if you're as impatient as I am, your fingers must be itching to get on to something else.

Step 5. Mix up five values for each color you plan to use, ranging from very dark to very light. To do this, place a dab of pigment (say blue) in five porcelain cups, add the egg-water medium (as described in Chapter 5) to each, and stir. Now mix in black and white: the darkest blue is mixed with a lot of black; the lightest blue with a lot of white; the three blues in the middle with appropriately less quantities of black and white. Medieval and early Renaissance painters underpainted many textures, such as flesh, with their color opposite. So for your portrait, you'll want five values of green. Once you've mixed them, paint the entire face in the middle

tone. The drawing will be obliterated, but the outlines will come through the partially transparent paint layer. Then model the darkest flesh areas by densely crosshatching with your darkest green and the lightest areas with a greenish white. Highlight the nose, chin, and forehead with pure white.

Step 6. Next come the flesh colors. Mix up five values of pinkish flesh color. Apply bright red spots to the cheeks and cover the face with the middle tone of the pink flesh color. Once again, you'll obliterate the drawing; once again you'll build the face up by crosshatching. Then you're finished.

Egg Tempera Today

The Cennini method suited the painters of his day admirably. Since they weren't interested in naturalism there was no need to show how the colors of forms are influenced by the colors of other objects around them. So the medievalists constructed forms out of *local color*. Local color is the color of an object as you might see it if the object were removed from all outside influences. For example, blue flowers seen in a white room under white light look completely blue. Of course, flowers are rarely seen in such a controlled situation, and today if you wanted to paint natural-looking flowers you wouldn't use local color. Instead, if you painted them, for instance, under a leaden, gray sky next to a bright red house you'd want a combination of colors to reflect these outside influences on the flowers.

Furthermore, medievalists painted two-dimensional forms. Putting forms in perspective was beyond their scope. So they simply crosshatched to indicate light and dark values instead of searching for a way to show the light and shadows of forms viewed in space. Today, of course, we usually put our figures into perspective. And one way to convey depth is through the use of glazes and scumbles.

A *glaze* is a layer of transparent color applied over a dry coat of another color that's lighter and more opaque. The effect is something like putting a piece of stained glass over a paler piece of colored cardboard, A *scumble*, on the other hand, is a semi-opaque layer of light color applied over a

dry layer of a darker color, usually opaque. A scumble resembles a light-colored veil, partially obscuring the underlying color.

When you glaze or scumble, the two colors combine to create a third color which seems to shine through the top layer. Glaze and scumble enough times and you have a number of colors which seem to move toward you from deep inside the picture, giving it a three-dimensional quality.

All of this is probably old hat to you, but it's not to traditional egg tempera painters of today. They still use local color and crosshatching as they were used 500 years ago, and they reject glazing for both showing perspective and producing tonal values as unsuitable for egg tempera.

This doesn't mean that all egg tempera painters today follow this method; they don't. Reginald Marsh is a good example of such an iconoclast. But most people who teach or write about the medium still worship Cennini's treatise as the bible of egg tempera painting. They feel his is the one and only way to paint, and they pass their fundamentalism along to students and readers.

I know; it happened to me. When I went to art school back in the forties our training included a course in egg tempera, a course described by students who had already taken it as tedious and restricting. They complained about how bored they were by the time they finally began to paint after having drawn identical India ink cartoons, first on paper and then on panel. And they hated the inflexibility of a technique that allowed no corrections or second thoughts. They threw their hands up in despair, and today I don't know of a single one who paints in egg tempera.

Having heard all this, I tried to get out of the class, but since it was compulsory, I failed—a failure I've never regretted. Before my formal introduction to the medium I'd been working in oils, but I wasn't satisfied with the way I handled them. Then I started the egg tempera class.

Almost immediately I found that the technique suited me. I could work the way I wanted and achieve results that I couldn't get with other mediums. I was an overnight convert, and I'm still intrigued by its possibilities.

But if recognition of my chosen medium was instantane-

ous, so was my rejection of the way it was taught. Every time I asked why I had to perform a "required" step I was told, in effect, "Cennini said so." Or if I asked why I couldn't do something else, like glaze, the answer was "If you want to glaze, stick to oil" or "Cennini didn't do it." All of which struck me a little like telling a poetry student that the only poems he could write had to be done in the style of *Beowulf*.

Fortunately, my professor was understanding and he left me to my own devices. In short order I realized that most of the rules that were valid for the old masters no longer held true. There were plenty of things I could do with egg tempera that my teacher didn't tell me, things that if the old masters were alive and painting they would probably try.

Yet even today, writers and teachers advocate tempera painting based on Cennini's principles. They modify them somewhat; not all insist on elaborate drawings on paper, for example. But they still advocate the use of local color and the detailed, crosshatched cartoon on a panel, making the technique seem as inflexible as ever.

Why I Paint in Egg Tempera

Egg tempera isn't for everyone. It has real advantages and disadvantages as well as subjective ones, and only you can decide if the medium suits you. Even illogical preferences can influence you. They do me. I have several idiosyncrasies that make egg tempera attractive. For example, oils strike me as greasy-looking, and I don't like that effect. Acrylics bother me because I don't like their smell—or maybe it's their non-smell. Unreasonable? Perhaps, but painters are only people.

More important considerations, however, dictated my switch from oil to egg tempera. I found that by capitalizing on the three major characteristics inherent in the medium I could expedite my work and at the same time improve its quality.

Quick-Drying Quality. Egg tempera dries to the touch within seconds. Some find this a bugaboo; they love working on a wet surface and will do anything they can to slow down the drying process. A few extreme painters have even gone so far as to paint with Vaseline to keep the surface wet as long as

View of the Sea, 28¾" x 35½". A scumble is a semi-opaque layer of light color applied over a dry layer of a darker color, which produces a light-colored veil. A perfect example of scumbling is the curtain in this painting. Collection, Mr. and Mrs. Richard Foxwell.

possible (with disastrous results, I might add). So if you like a slow-drying medium, you'd better forget egg tempera now.

If you don't, you'll appreciate this characteristic. I've always liked working on a dry surface and hated waiting for paint to dry before continuing. Since I build up form by applying a succession of glazes I'd have to stop for days or weeks between each layer of paint if I worked in oil. In fact, before I discovered egg tempera, I used to add siccatives to oil paint to make it dry more quickly.

Of course, watercolor and gouache also dry quickly, but my passion is glazing and neither medium is particularly suited to this technique.

Textural Effects. Texture fascinates me. I love the graininess, the defects, the bumpiness of materials such as concrete, rock, and brick. Egg tempera is an ideal method to render these qualities. You can dab or splatter (many artists use the term "spatter"; I prefer the word "splatter") the paint, and then glaze over it until you get the exact roughness you're looking for. If you don't, you can scrape it out with a razor blade and start over.

Rough textures—and by this I mean the look of the texture, not the rough quality of paint on canvas or panel—are more difficult to obtain in oils and practically impossible in acrylics. Acrylics dry fast, but unlike egg tempera, they form a rubber-cement-like finish so you can't play around with textures, scraping out here or sandpapering there; the surface is too hard or rubbery.

Luminosity. No other medium can match the beautiful luminosity of egg tempera. Exactly how it differs from the luminescent qualities of oil and acrylics is hard to explain. To say that an egg tempera painting has a shimmering or glowing quality accented by jewellike tones is an imprecise description but it might give you an idea of the characteristic. It really must be seen to be appreciated.

And you can't destroy this beauty. The luminosity of egg tempera is enhanced, rather than diminished, by repeated layers of transparent color. Should an area of paint dry without this life-giving quality all you have to do to restore it is apply another glaze. This isn't so with other mediums. Glaz-

ing with oils or acrylics must be done with care, or colors will get muddy and greasy-looking rather than luminescent.

Glowing light and subtle textures are the essence of my paintings, but many painters today aren't interested in beautiful effects such as these. These artists have had various names applied to them over the years: in the early sixties, they were called Pop artists; a decade later they were renamed "sharp-focus" painters, or more commonly "New Realists." The New Realist looks at life with a cool-headed objectivity, recording (in sharply focused detail) what he sees with a clarity and intensity that allows the subject to speak for itself. Objects are starkly visualized without any mitigating forces of mood or impressionism. They are what they are. The rationale behind this movement is that because the world is harsh and ugly, art should reflect its harshness and ugliness. Paintings should be like photographs without delicate nuances. Ours, the New Realists say, is not an age of subtlety; ours is the age of the billboard, the magazine ad, the television commercial. And for these artists, the hard, cold gloss of acrylics is indeed a boon.

I don't share the philosophy of the New Realists. A strong indictment of society can be made just as easily by using a subtle approach. Certainly Goya's depictions of the evils of war as a protest against society are unequaled. Yet they are beautiful paintings. And that's what I think art is all about. So egg tempera with its power to enhance beauty is the medium for me.

And it may be for you. That's why I'd like to explain how I use egg tempera and demonstrate to those of you who might be scared off by traditional teachings its value as a twentieth-century technique. You can take it from there. Since there are no hard and fast rules (except some chemical limitations, as all mediums have), you can make your own. You can slather, splatter, stipple, and sponge. You can start right in on a panel with a paintbrush. You can change your mind and scrub it all off if you don't like what you see. In other words, you can defy all the old rules, toss the 500-year-old tradition out the window, and use egg tempera the way you want. In the process, we can revolutionize an ancient technique and make it relevant to twentieth-century painting.

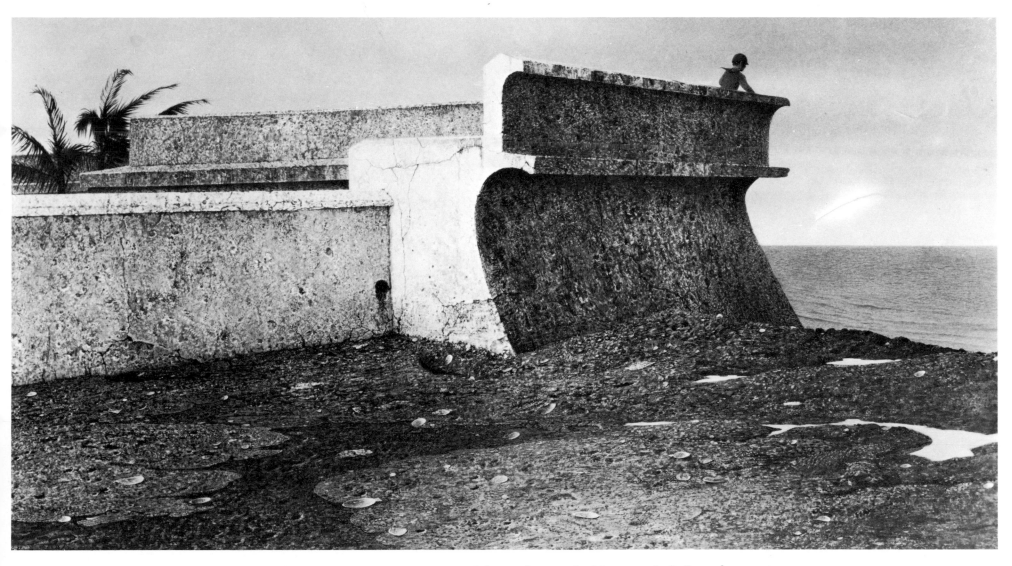

Looking Out to Sea, 19″ x 34″. Here I was fascinated by the textures created by coral covered with seaweed, shells, and sea water. The wall, which actually exists, is an example of a functional object with linear beauty. Collection, Mrs. J. Frank Forster.

Afternoon Dark, 24" x 36". *Skies are easier to blend in oils. But you can learn to produce a good sky by scumbling or stippling and sponging. If you sponge, as I did in this painting, use thin paint and work over it until any holes left by the sponge vanish. Collection, Mr. Allan I. Bluestein.*

2. Limitations—Real and Imaginary

Some years ago *Time* magazine flew me to Morocco to paint a cover portrait of Princess Aisha, an important political figure and feminist in her country. When I went on such assignments I took along only my brushes and paints. You can't mix the egg yolk medium with pigments in advance so I always bought eggs on location, a far more convenient arrangement than toting around a box of eggs hoping they won't break. And eggs are always available.

Or so I thought. Just before the Princess' car arrived at my hotel to take me to the palace, I phoned room service and asked in my high school French for an egg "not cooked." Up came a soft-boiled egg. I sent it back explaining more carefully this time that I wanted an uncooked egg. The bell boy returned with an even softer-boiled egg. The language barrier became insurmountable; no matter how hard I tried I couldn't make him understand that I didn't want to eat the egg. At this point the kitchen closed.

My predicament worsened when I realized it was siesta time and all the stores were closed too. Only the hotel bar was open. I rushed to buy an egg from the bartender, but this time I ran up against another obstacle. It seemed it was a rule that food couldn't be sold at the bar. If I wanted to drink an egg in a Tom and Jerry or an egg nog, fine. Otherwise, no. After many attempts to explain what I needed the egg for, I lied and said that I wanted the egg for a still-life painting. Smiling thinly, and figuring that I really wanted the egg for some dubious orgiastic rite, he finally sold it to me—at five times its usual price.

Real Limitations

This story illustrates one of the real disadvantages of painting with egg tempera—eggs aren't always available. Granted my Moroccan experience was unusual, but others have encountered similar difficulties. Peter Hurd, for example, when he was painting as a war correspondent during WW II, was unable to get eggs. His solution was the same one he used to satisfy his nutritional needs: powdered eggs. Here are some other limitations:

Impasto. Pigments mixed with egg yolk must be applied thinly or they'll crack and fall off. Building up impasto as oil painters do—by brushing on thick paint or lobbing it on like Jackson Pollock—just won't work. Apparently there's only enough adhesive power in an egg to make thin layers stick. This disadvantage can be overcome by building up paint in many layers. But the painter attracted by big, bold, heavily loaded strokes should keep away. Oil or acrylic is the medium for him.

Blending. Here again oil triumphs over egg tempera. Adjacent values can be so perfectly blended in oil that you can't see the gradations. Blending values in egg tempera, on the other hand, is far more difficult, particularly if the area is large, because the paint dries so rapidly. For example, if you want to paint a sky with the darkest part at the top, gradually lightening as it nears the horizon, you may end up with streaks or irregularities at first. But with practice the beginner can learn to paint scumbles quickly and smoothly.

Lighter Colors. Oil and acrylic have a deeper range than egg tempera. In other words, the darkest dark in egg tempera won't be as dark as the same color in oil. Pure black, for instance, in egg tempera is about as deep as dark gray in oil. So if you're looking for very rich deep tones, stick to oil.

Linearity. Egg tempera dries to a matte, flat-looking finish and this tends to make the medium more linear. I don't

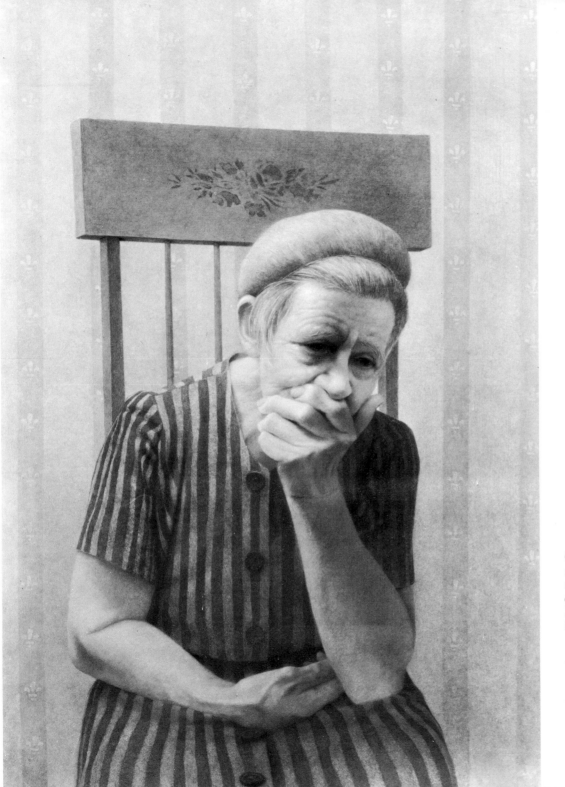

Old Woman (Left), 24″ x 18″. This painting, done when I first began to work with light and shade, is rather linear. There are highlights, shadow edges, and reflected light, but hardly any cast shadows. Compared to The Magic Carpet, it almost looks like a bas-relief. Collection, Syracuse University Art Gallery, Syracuse, New York.

A Saucer of Cream (Right), 28″ x 30″. Notice the echoes in this painting: the saucer and the manhole; the painted lines; the curves of the cats' tails and the child's legs. Courtesy, Midtown Galleries.

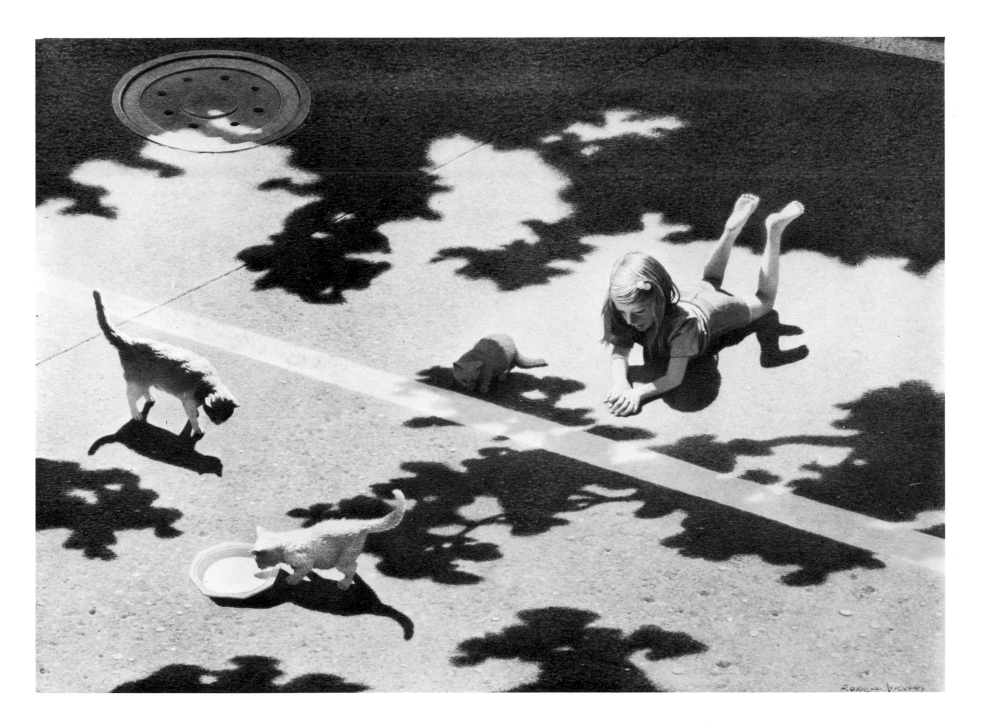

consider this a limitation because I have an affinity for drawing, but some painters don't.

Imaginary Limitations

Before I go any further, let me re-emphasize a couple of points. Egg tempera has several real limitations (it cracks off if improperly applied and it's hard to blend because it dries quickly) and several subjective limitations (its higher color register, its linear quality). These qualities may seem like weaknesses to some, strong points to others; all, however, are valid objections. But there's another category of limitations that I call imaginary. They're talked about in classes and spelled out in books, but for me they're nonexistent.

Rigidity. Ever since Cennini's day, teachers and scholars have condemned work-in-progress experiments. The *Encyclopaedia Britannica* says about egg tempera: "a deliberate, controlled method adaptable to carefully planned work, rather than spontaneous painting." In other words, you either plan the composition in advance right down to the last brushstroke and then execute it exactly, or you don't paint in egg tempera. That's the rule, but it just isn't true. One of the beauties of egg tempera for me is the latitude it allows. When I begin a painting, the only thing I might work for is a color scheme. And if I miss it at the beginning, I scrape the paint off and start over. But traditional egg tempera painters insist on carefully thought-out compositions because they assume the quick-drying quality prohibits experiments. Nonsense. Egg tempera is the easiest technique of all to correct or improve. I think the old method is like an express train. Once the artist gets on there's no getting off. He works his original cartoon straight through to its predetermined end. My way is more like a local train from which you can disembark at almost any point to explore the countryside.

Small Scale. Another mistaken belief is that egg tempera paintings must be small. This is pure mythology. Botticelli's *Allegory of Spring* and *Birth of Venus* are huge and so are some of the other old masters' paintings. The real reason, it seems to me, why traditionalists don't advise working on a large scale is that painting a big picture *à la* Cennini would bore the painter to death. Most people just don't have the patience or stamina to draw an enormous cartoon one or more times and then put in millions of tiny crosshatches. If I attempted such a project I'd probably be carted off to an asylum before it was finished.

Two-Dimensional Quality. Many authorities on egg tempera believe that the medium doesn't suit a naturalistic approach; they think that naturalism is better off left to the oil painter. And perhaps they're right. Certainly this is true if they present forms in local color and avoid perspective as they did in the trecento and early quattrocento. But the painter who masters the use of glazes should have no trouble creating marvelous naturalistic effects. After all, who could be more naturalistic than Andrew Wyeth?

Marble Player, 11¼" x 16". The marbles in this painting look extraordinarily three-dimensional. I achieved this by putting in strong shadows underneath the marbles and highlights on top of them. Courtesy, Midtown Galleries.

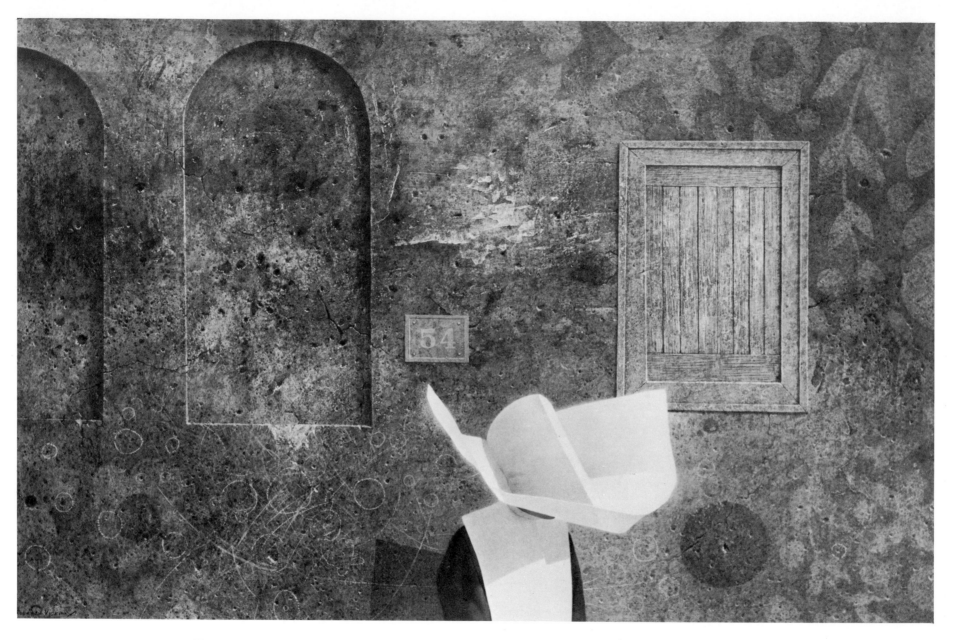

Number 54, 24″ x 36″. This painting has a little bit of all my techniques in it. The flowers on the right were stippled with a housepainter's brush; the crumbling area over the nun was done with a palette knife; the wood was drybrushed and scratched with a razor blade. Collection, Mrs. John C. Fergus.

3. Brushes and Other Equipment

I once saw a picture of Kandinsky's studio in a book. Brushes and knives were lined up with military precision and hundreds upon hundreds of paint jars were meticulously arranged by category—the studio was a masterpiece of organization. In the same book was Francis Bacon's studio—a masterpiece of disorder. A palette from which paint rose to a plateau several inches high exemplified the confusion. Apparently Bacon never scrapes off old paint; he simply adds more each day.

My working habits are a compromise between order and chaos. I use a clean palette every day and I arrange pigments by color in old chests of drawers. But I scatter brushes and knives, and I fill old cabinets and shelves with books, reels from my movie-making days, records, a hi-fi set, a radio, and a television. The last items are hardly essential to every painter, but they are to me. Listening to (not looking at) old movies on television has a particularly soothing effect—perhaps they engage that part of my brain that might otherwise interfere with the work of my hand. Whatever the reason, with the help of these modern machines, I can concentrate completely in my old boathouse under the Cape Cod pines that I converted into a studio.

I've described my studio as well as other painters' to illustrate that work areas and habits are highly idiosyncratic. And so are artists' materials and tools. I have, for example, old tools as well as new; cheap equipment and expensive; store-bought gear and home-made. Some are general painting tools; others are specifically suited to a traditional egg tempera painter; still others are for an iconoclastic tempera painter like me. To show you what I mean, here's a list of materials and tools I've used over the years. It's by no means a complete catalog of products an egg tempera painter might be interested in. Rather it's my personal list of materials and tools I've tried and either liked or rejected.

Sable Brushes

Sable brushes are a must for most egg tempera painters. No matter how far you stray from conventional painting techniques, you still end up with a certain amount of fine detail work, and there's no better tool for details than a good sable brush. I prefer a brand called Finepoint (manufactured by Art and Sign Brush Mfg. Co.) in a size range from No. 1 to No. 8. These brushes come to a better point than other brands I've tried, and they have another advantage: as hairs break off with use, Finepoint brushes maintain their points. Some of my prize brushes are quite battered. Yet even though I've had them for years, they get better and better for certain jobs. In fact, instead of changing to a very small brush, say a No. 00, for minute detail work, I'll use an old medium-sized brush because its hairs are longer and come to a better point.

Bristle Brushes

I don't like bristle brushes. Oh, I use them occasionally to scrub paint around, and it's certainly a better idea than using a large sable brush. A sable brush that size might cost $35 or so and it wouldn't last long since scrubbing causes hairs to break off. (Scrubbing—a motion similar to the application of shaving cream by a brush—is anathema to traditional egg tempera painters, so they would never use a brush for this purpose.)

But, in general, bristle brushes are impractical for egg tempera because they're made for pushing around thick oil paint. Furthermore, the bristles are unyielding—like little wires—and tend to make grooves in the paint surface. In other words, if you were to look through a magnifying glass at a panel after laying in a wash with a bristle brush, the surface would seem like a plowed field. Even worse, the

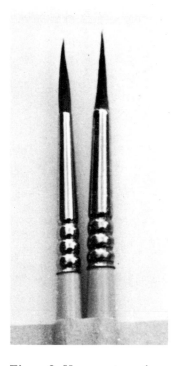

Figure 2. Here are two of my sable brushes. The one on the left is brand new, but the older brush on the right comes to a better point.

ridges of the furrows might be so caked with paint that they could crack and fall off. The same holds true for dabbing paint on. Bristle brushes perform this task admirably for the oil painter, but dabbing thick paint on in egg tempera is chemically taboo. So there's no point using a brush that's self-destructive.

Housepainter's Brushes

Some of my favorite brushes are housepainter's brushes made of hair. They're far better than bristle brushes because they're flexible, they hold paint well, and their hairs separate easily so you can achieve textural effects. And their versatility is almost endless. They're great for laying in large washes, scrubbing, dabbing, stippling, and many other jobs. What's more, they're cheap, so get the best. Hairs fall out of cheaper brushes easily, and there's no sense sacrificing quality

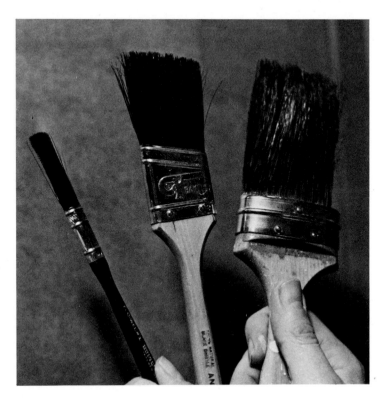

Figure 3. I use these three old housepainter's brushes for creating textural effects.

for a few pennies. Size depends on the type of job you want to do. I have housepainter's brushes as small as half an inch and as big as four inches.

I stay away from housepainter's brushes made of nylon, however. Their hairs won't spread; they cling together, a phenomenon that doesn't satisfy my urge to create texture. Furthermore, their tips are frequently tapered. A flat-edged brush such as a housepainter's brush does a better job for most things.

Stipple Brushes or Stipplers

Sign painters use a brush called a stippler, but I don't like it. It's okay for putting in solid color as a sign painter does, but no good for any irregular effects because it has very short hairs which won't bend. For the kind of stippling I do, I'd recommend a housepainter's brush made of hair.

Knives

I love knives, particularly palette knives, for applying paint. Over the years, I've become more and more adept at putting paint on with a knife. It's easy to apply paint in thick layers, but putting it on thinly to prevent cracking takes more practice. Now I can get the most delicate skin tones with a knife. I find that it's easier to do this with a palette knife (a tool usually reserved for taking paint out of a jar) than a painting knife (a smaller tool frequently used by oil painters to apply paint) because a palette knife is less flexible than the painting instrument and easier for me to control.

Sponges

Another of my favorite tools for creating texture is a commercial sponge. Fleecy clouds and flaking walls are just two of the many irregular patches of paint you can dab on with a sponge. The textural variations are almost endless, and so are the shapes a man-made sponge can assume. If you want an absolutely flat surface with sharp corners, you've got it; if you want rounded edges, shape them with a scissors; if the sponge is too big, cut it down to size. Natural sponges are far

less versatile; they are uneven in shape, unwieldy, and difficult to cut.

When you're buying sponges keep in mind their color. Since I usually use a sponge only with white or light colors, a darker sponge helps me see how much paint I have on. But if I applied, say, yellow paint with a yellow sponge, I wouldn't be able to tell.

Facial Tissue

This product has become a popular device in many a painter's bag of tricks, but not mine. Occasionally, I might dip a tissue into paint and plaster it on the panel to get a strange texture, but on the whole, I find tissues less than satisfactory.

Rags

You can create certain effects with rags, as you can with facial tissue. But I save mine—usually old sheets torn into small pieces—to clean brushes.

Cheesecloth

I'd never be without a large supply of cheesecloth because I use it for so many things. It's far superior to tissue or rags for achieving textural effects. And it's good for straining egg yolk when mixing the medium, and invaluable for blotting and smearing paint around. If you find cheesecloth the wonderful tool I do, make sure you buy a good grade. Cheaper grades come in layers that are hard to separate and cut.

Sandpaper and Razor Blades

Both of these products are absolutely essential to the egg tempera painter who paints as I do. I sometimes use them to create textures, but their most important job is to make corrections. Sandpaper comes in many grades, from very fine to very coarse, and each serves a different function. A coarse quality works well for sanding out a large area in a hurry or removing paint that has dried, but a finer grade is necessary to finish the job before repainting can begin.

Concrete Tree, 26" x 20⅜". *The white line in this painting is a good example of stippling, this time done with a bristle brush. I used a bristle brush rather than a housepainter's brush because the area is so small. Courtesy, Midtown Galleries.*

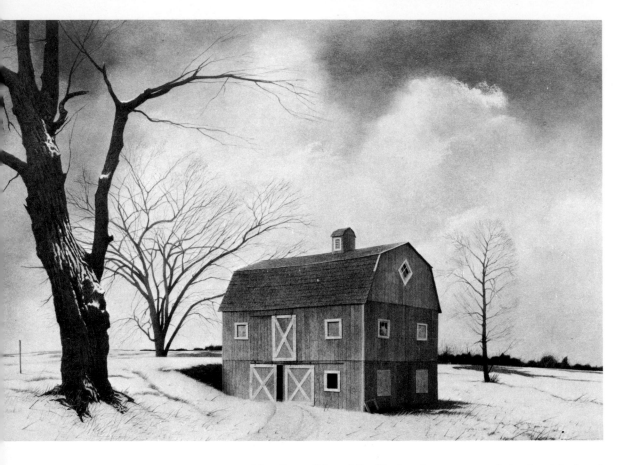

Blue Barn, 24" x 36". *Notice the sponge mark in the right-hand part of the sky. Usually I rework the sky with my sponge until the texture is quite even, as I did with the rest of the sky in Blue Barn. But I liked this one area so much I didn't change it. Collection, Mr. and Mrs. Joel Dolkart.*

Corrections can be made with both single- and double-edge blades. For example, if you want to eliminate an area of paint, scrape it out with a single-edge blade. If you want to scrape off one layer yet leave the paint underneath it intact, use the more flexible double-edge blade to perform this delicate surgery. Both blades should be handled with care, however. Before you start scraping with a single-edge blade, sandpaper the corners down so you won't damage the panel should you accidentally dig the edge of the blade into it. And cover one edge of a double-edge blade with tape so you won't cut yourself.

Easel

The choice of an easel is strictly personal and has nothing to do with the medium. The only advice I would offer a prospective buyer is to get a sturdy one; the rest—the frills or lack of them—is up to the painter. But I do have some advice for artists who work on large panels and who like to work sitting down. If you're searching for an easel with notches that lower the adjustable holder to the pedestal at the base, forget it. They can't be found at any price. I know, I've been looking for twenty-five years. Instead, easel manufacturers frustrate painters like me by stopping notches about a foot or a foot and a half from the floor. My solution to the problem is to take the easel apart and drill additional holes below the lowest notches on both sides of the upright. Then I insert large nails in appropriate notches, depending on the area I'm working on. If, for example, I'm painting the very top, I can slide the holder down almost to the floor.

Table

Again, it's the painter's choice. Some use taborets covered with gleaming white glass; others are less elegant. One painter I know uses an old fish cleaning table. My selection is pedestrian but functional: a card table.

Lighting

North light is ideal, of course, but the structure of my boathouse-turned-studio dictated a northeast skylight. Not

that I care much. At least half of my painting time is spent after dark so artificial light is just as important to me.

My night-time system is crude but it works. I nailed a large piece of glossy white cardboard backed by plywood to one wall at an angle and lit it from the bottom by a fluorescent light and from above by three blue daylight bulbs. Reflected light comes over my left shoulder and is similar to the natural light which comes in from the skylight directly above the reflector.

Mirrors

Hand mirrors help me in two ways. First, when I work on a painting for a long time I can't see its faults because I'm so familiar with it. A mirror reverses the image and gives me a completely fresh viewpoint. I'll immediately notice an eye that's too big or a lopsided face. Second, some trouble spots are so subtle they can only be seen from a distance, and a mirror doubles the distance from the painter to the picture. Since I work sitting down, a mirror saves me from getting up to look at the painting from several feet away.

Acetate

Another invaluable material for the non-traditional egg tempera painter who works and reworks his composition as he paints is an acetate that looks like heavy cellophane. Suppose, for example, that I'm not quite sure where I want to put the glider in *Gliders*. Instead of painting it on the panel and scraping it out if I don't like its location, I could paint a glider on a piece of acetate, which adheres to the panel by static electricity, and move it around until I find its proper place. The acetate I use is called Protectoid, a very thin, crystal-clear acetate that's so stable you can paint on it with watercolor if you wish.

Tracing Paper

While not quite as convenient as clear acetate, tracing paper serves the same purpose. I sometimes use it instead of Pro-

tectoid when I want my compositional sketches to be larger or more detailed.

Drafting Tape

I use drafting tape in a number of ways: to attach tracing paper to the panel; to protect an area I don't want to harm by erasing; to act as a mask when I splatter. And I always use drafting—not masking—tape. Masking tape is stickier and tends to pull paint off the panel when it's removed.

Figure 4. Here's an example of how tracing paper helps me decide on the composition of a painting.

Big Flower (Left), 18¾" x 22". The texture of the pavement was created by laying in a wash of ochre and umber, underpainting with pinks and greens, and splattering and glazing with brownish tones. Courtesy, Midtown Galleries.

Sister (Above Right), 24" x 36". The background of this painting has a great deal of paint applied by palette knife. The letters were stippled in through commercial stipple forms, but the blocks of old paper were created by masking off edges with drafting tape and then applying paint with the knife. Collection, Dr. and Mrs. Dana Mitchell.

Late Afternoon (Right), 26" x 37". My old studio in New York City had a west skylight, and every afternoon I was forced to move to the other end of the room. One day before I changed the position of my easel, I noticed the beautiful shadows underneath and decided to paint the scene. Collection, the Butler Institute of American Art, Youngstown, Ohio.

Aerial View, 20″ x 30″. Patched concrete streets remind me of an aerial view of a landscape. In this painting, I organized the design so the viewer might think he was looking down from a plane at the fields and roads below. Private collection.

4. Panels, Pigments, and Palettes

Many materials and tools used by egg tempera painters are the same as those used by oil and acrylic painters, even by watercolorists: brushes, knives, easels, off-beat materials such as sponges and cheesecloth can all be swapped back and forth. But when it comes to painting surfaces and pigments, the egg tempera painter's range narrows. For example, an oil painter can work on either canvas or panel and he can use commercially manufactured tube colors or homemade, hand-ground colors, depending on how much of a purist he is. The egg tempera painter doesn't have this freedom.

Panels

Egg tempera can be applied to canvas if it's specially treated and attached to a panel, but wood is a far more convenient carrier. Cennini used panels of "whitewood or poplar, linden or willow." Today we're more prosaic, and most egg tempera painters, including myself, use an ordinary wood pulp panel material (one brand is Masonite), available in several thicknesses at nearly every lumberyard or hardware store in the country.

Before panels can be used, however, they must be sized and treated with gesso, a mixture of a chalky pigment (whiting), glue, and water. Gesso gives the panel a fine tooth so paint will cling to it. And here's the rub: good gesso panels are hard to come by. You can make them yourself—the economical, but not always preferable, way—or you can buy them. Let's look at the alternatives.

Buying Handcrafted Gesso Panels

A really good gesso is composed of chalk and an animal-hide (usually rabbitskin) glue, and applied by hand. Skilled gessoers are going the way of all craftsmen, and no wonder. A handmade panel can cost as much as $2.00 a square foot. So handcrafted panels are a real luxury, and one that isn't necessary unless you decide to make a career out of egg tempera painting.

Still, if you don't mind spending the money for quality, you might try your local art school. Many art students are anxious to make extra money and they usually do a good, careful job of gessoing. My own experience with students at the Paier Art School in New Haven, for example, has been satisfactory. The panels aren't always the prettiest in the world—they frequently need some sandpapering to smooth out excessive roughness—but they're of good quality.

Making Your Own Gesso Panels

The process isn't complicated but it can be tricky. I know. That's why I began to buy gesso panels after years of making them myself. Still, it's far more economical so the process is worth exploring.

First, buy an *untempered* panel at a lumberyard. Tempered panels look good but contain an oily component which threatens the adhesion of the paint. If the tempered product is all you can get, scrape it down with sandpaper as hard as you can until the shine disappears. Even if the board is untempered, it still needs a little sandpapering to increase the tooth so the size will adhere better. If both sides of your panel are smooth, then sand down the second side as well.

Sizing the Panel

Size is a glutinous substance used to fill the pores of the panel to prevent the gesso from being absorbed into them.

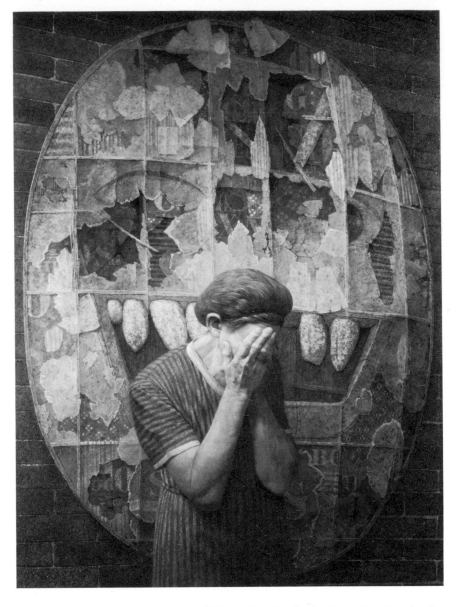

Woman Weeping, 59½″ x 42″. Look closely at the face in the background. I saw a similar face on a charred poster clinging to a burned-out funhouse in Coney Island. Collection, Colorado Springs Fine Arts Center, Colorado.

I suggest you use leaf gelatin for both sizing and gessoing because it's easier to get, less expensive, and nearly as good as rabbitskin glue. As a matter of fact, I used cooking gelatin for years until I read an article saying it wasn't strong enough and switched. But until you're sure egg tempera is your medium, stick with gelatin. Here's my recipe:

Step 1. In the upper pot of a double boiler, sprinkle one part leaf gelatin over 16 parts cold water. (An ounce of gelatin and 16 ounces of water should be enough for half a dozen medium-sized panels.) The gelatin will absorb the water in about 10 or 15 minutes and swell to several times its original volume, looking like a big lump of mush.

Step 2. When all the water has been absorbed, place the pot in the bottom half of the double boiler containing boiling water. Don't place the gelatin in a pan directly over flame because, unless you're very careful, the solution will boil, reducing the strength of the gelatin.

Step 3. As the mush heats, stir the mixture with a teaspoon until the gelatin dissolves and the solution looks clear. The clear solution is the size.

Step 4. When the gelatin has completely dissolved, remove the double boiler from the stove and keep the two pots nested together to prevent the solution from getting cool while you work. Cold gelatin will set on the panel and become unworkable.

Step 5. Dip a large housepainter's brush into the size and brush the entire surface with scrubbing strokes, running in as many directions as possible to avoid the grooves made by even strokes.

Step 6. Turn the panel over and repeat the process. The panel must be sized and gessoed on both sides to prevent warping.

Step 7. Allow the sized panel to dry to the touch before applying gesso. Gradual, even drying is essential, so keep the panel away from both direct sun and damp places. Some writers say the panel should dry overnight or for at least half a day. I've found that drying depends on the weather: on a warm, dry day it may take as little as an hour.

Mixing the Gesso

Gesso is the same thing as size with the addition of whiting (or precipitated chalk, an artificial whiting), which hardware stores supply.

Step 1. Repeat Step 1 of "Sizing the Panel." (If you use the same amounts, you should be able to gesso several medium-sized panels.)

Step 2. Weigh out 1½ ounces of the powdered whiting to 1 liquid ounce of the size solution.

Step 3. When the size is ready, take the double boiler off the stove and gradually add the whiting with a teaspoon. Work quickly because you don't want the mixture to get cold and turn to jelly, but don't throw the chalk in all at once because air bubbles may form.

Step 4. When all the whiting has been soaked up by the solution, stir the mixture gently with a brush handle and turn it into a pan or bowl.

Step 5. Wash out the top pot of the double boiler, and place several thicknesses of cheesecloth over its rim. Fasten them down with a piece of string or elastic band.

Step 6. Gently push the mixture through the cheesecloth with your brush or a spoon. Straining completes the mixing of the size solution and the whiting.

Step 7. By this time the gesso may have solidified into a jelly. If so, put the top back on the bottom of the double boiler still containing hot water and stir with a teaspoon for just a moment until it re-liquefies. As soon as it does, remove it or you run the risk of adding air bubbles.

Applying the Gesso

If the gesso has the consistency of a smooth, thin cream, you're ready to go ahead.

Step 1. Apply the first coat of gesso with a large housepainter's brush. Stroke from the left edge of the panel to the right, or from the top to the bottom.

Step 2. Wait a few minutes before applying a second coat. The gesso should be dry to the touch and appear dull or matte when you look across it before you proceed.

Step 3. Change the direction of your brushstrokes. If you ran your strokes from left to right in Step 1, run them up and down. I described paint applied by a bristle brush as a plowed field when viewed under a magnifying glass. Gesso produces the same effect, and if all coats are applied in the same direction, the furrows get deeper and deeper.

Step 4. Repeat Step 1.

Step 5. You can stop after three coats or you can add two or three more. Just make sure that you've built up enough thickness so that all brush marks can be sandpapered out and you still have a good, even coating of gesso.

Step 6. Repeat this process on the other side of the board.

Step 7. When the gesso is bone dry, smoothing the gesso panel is the last step. Some painters scrape the surface with a scraper, others with a stone, but I use sandpaper. Just how much sanding the panel needs depends on the painter's textural preferences. If you like a rough texture, sandpaper lightly. If you like a smooth surface, work harder. I once saw a man work so hard on a panel he wore the flesh right off his fingertips. After sandpapering the panel, he wanted an even smoother surface, because a sandpapered panel is still full of tiny scratches. So he wet the surface and rubbed it with the palm of his hand and his fingertips to get it completely smooth. As he worked, he wore through the layers of skin so gradually and painlessly that he began to bleed before he realized what he'd done. I think he carried the step too far, but it's up to the individual.

Problems and Solutions

Earlier I said the gesso process could be tricky. You may be wondering how anything could go wrong with such a simple procedure. Well, to begin with, you could misjudge the amount of gelatin necessary to make the gesso cling to the surface. If you use too much, the gesso cracks violently;

too little and it powders and flakes off. In either case, the result is almost immediate. As a general rule, if defects don't show up within two weeks (the amount of time it takes gesso to dry thoroughly) you're safe.

Adverse weather conditions might also affect the panel. I know a painter who put a panel out to dry on a cold winter day. It froze and cracked, but this was an unusual occurrence. Most people would have better sense. Gesso panels should be allowed to dry in an atmosphere that is not overly warm, dry, damp, or cold.

Air bubbles cause the real problem. Stirring the mixture too strenuously, adding the chalk too precipitously, heating the mixture too much immediately prior to application, all can produce little pockets of air in the gesso which remain when it's transferred onto the panel. Then, because the mixture sets so quickly, the bubbles become trapped and create pinpoint holes so tiny you can't push a brush in to fill them. Even if you cover the panel with many layers of paint you can never get rid of those tiny white dots. The overall effect looks disconcertingly like snow. So let caution and moderation be your guides when mixing and applying your gesso.

Buying Mixes

If you don't want to be bothered with all the mixing and cooking involved in the do-it-yourself process described here, you can buy mixes that eliminate several steps. But beware of what you're buying. I've tried both powdered gesso, which contains rabbitskin glue and chalk, and liquid gesso mixtures. The former is chemically pure; the latter is not. Preservatives have been added to prevent the liquid from drying out, and once again I question the validity of using a product containing impurities. Also watch out that you don't buy an acrylic gesso mixture. You can't always apply egg tempera over a panel coated with this product.

Pigments

My tax accountant frequently complains that I don't spend enough on materials. I can't. Good rabbitskin glue panels are fairly expensive, but powdered pigments are cheap, particularly if you buy in large quantities. Unfortunately, like the handcrafted panels, powdered pigments are getting a little scarce. Not all the big companies carry them any more, although Grumbacher, Bocour, and Fezandie and Sperrle still do.

Storing Pigments

Many people think powdered pigments are a nuisance. They're not really; only a little extra work is involved in taking care of them. Here's what you do:

Open a bottle of powdered pigment, transfer half of it to an empty pigment bottle or baby food jar—baby food jars make marvelous containers—and pour a little water into it. (Skip this step for titanium white and ultramarine blue, but more of that in the next chapter.) Put the lid on tightly and shake the bottle vigorously until it forms a paste. A bottle should last several days if you're painting fairly steadily. Keep a watch on your bottles of paste while you're using them, however. You may occasionally need to add a little water if they seem to be drying out.

Some painters ask their color dealers to mix powdered pigments into a paste for them. This is all right if you're buying only a couple of bottles at a time. But if you buy in large quantities, as I do, they can mold when the paste begins to dry out, and no matter how airtight you think your lids are, eventually some air gets in. I know from unfortunate experience, for example, that cadmium yellow medium is prone to blooming (molding) when left in a bottle for a long time. If you should notice a discoloration in a paste, throw the bottle out. There's no point in trying to save it.

Color Variation

Unlike tube colors, batches of powdered pigment differ violently. For example, one shipment I ordered of viridian green came in quite blue. Since I work for an overall color scheme made up of different pigments, I was able to compensate for this by adding ochre until I reached approxi-

mately the right combination. But if I were trying to match pure viridian from one batch with another without adding other colors, it would be nearly impossible. Painters working in local color also face daily crises if they have to use the same color from one day to the next. To make sure they can match colors the next day, they store the pastes in their porcelain or metal cups by putting wet rags over them. When my day is done, however, I simply throw out what's left, unless I find myself with a lot of leftover paste. Then I place a glass, which has been rinsed but not dried, over each puddle of pigment, with a weight on top of the glass to prevent the moisture from escaping.

Mixing Colors

Traditional egg tempera painters regard mixing colors as a slovenly habit. They believe mixing muddies colors, destroys purity. They would rather have an enormous number of colors on their palette than try to make one color out of several. I don't agree. My palette consists of a few colors I use all the time—yellow ochre, cadmium yellow medium, burnt umber, titanium white, cobalt blue, viridian, cadmium red medium—and some I use infrequently—ivory black, ultramarine blue and alizarin crimson. People are amazed that I paint with so few colors, but I've never been accused of muddy tones. On the other hand, I wouldn't recommend the colors I like to anyone else. You must experiment for yourself before choosing pigments you think mix well with others. My only point is that contrary to orthodox opinion, simplicity is possible with egg tempera.

Pigment Peculiarities

While I would never advise anyone to copy my palette, I've learned a thing or two about the pigments I use and I'd like to pass on to you some of their quirks.

Cadmium Red Medium. A fantastically strong pigment—a small jar lasts me several years. But when I put it on my palette I add water to the paste frequently because it dries quickly in air. The paste smells like a salt water swamp at low tide so don't be alarmed by the odor.

Decorated Maze, 36″ x 24″. After finishing underpainting and glazing the wall, I began to add the chalk flowers, an extremely tedious process; the flowers had to diminish in size as they receded in space. To keep my sanity while I worked, I painted only four square inches of decorations each day. Collection, Mr. Thomas Congdon.

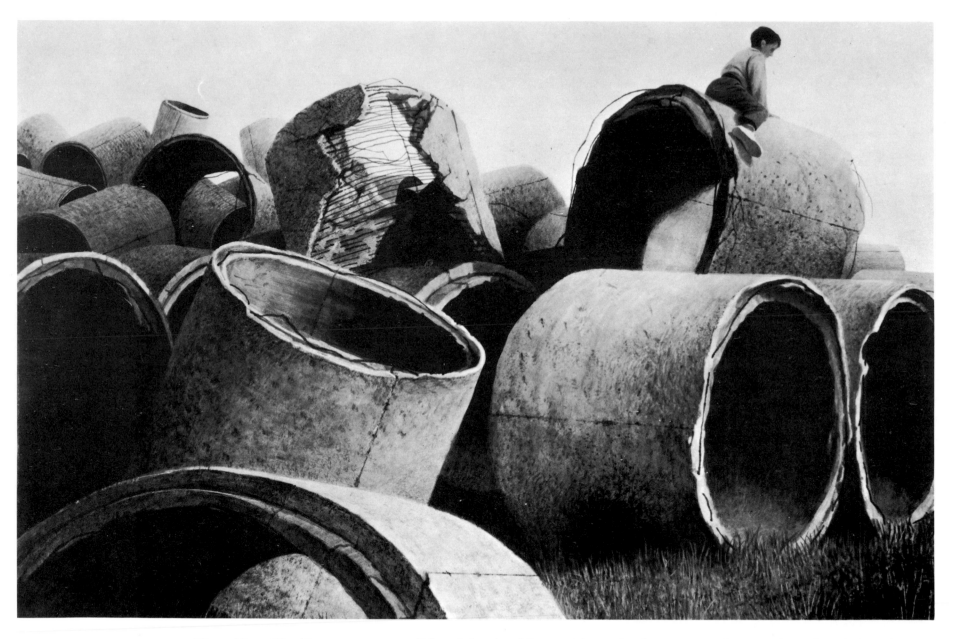

Pipes, *20″ x 30″. Tempera on paper. Although I painted Pipes with powdered pigments and egg medium, I worked as if I were painting a traditional watercolor. Instead of using white paint, I allowed the white of the paper to come through in the light areas. Collection, Mr. Herbert Adler.*

5. Making Egg Tempera

There's a story about John Singer Sargent and a woman who examined one of his paintings and remarked that his technique was sure to cause a great deal of cracking in years to come. He is said to have replied: "Madame, I am a painter, not a chemist." I, too, am a painter, not a chemist, but I don't share his disdain for my chosen medium. True, the exact proportions of albumin, water, and oil in an egg escape me, as do some other technical aspects of egg chemistry. But I still think it's important to have a general idea of how the medium of egg tempera works.

The Mechanics

To make paint you need three things: powdered pigment, an adhesive to make the paint adhere, and a solvent to thin the paint. In oil paint, linseed oil is the adhesive and turpentine is the solvent. In watercolor, gum arabic provides the adhesive and water is the solvent. In the egg tempera formula I use, the adhesive is egg yolk and the solvent is water.

All this is basic knowledge, and while I'm on the subject of basics, I'll define a few terms so you'll always know what I'm talking about. Egg tempera is the medium I work in, but from now on when I refer to *medium*, I mean the adhesive—the egg yolk thinned with water; by *pigment*, I mean the powdered pigment mixed with water into paste; and by *tempera*, I mean pigment plus medium.

The distinctive characteristics of egg tempera—quick-drying ability and permanence—are the result of the medium being an emulsion. An emulsion is a stable mixture of oil particles suspended in water. Soapy water is an example of an emulsion. So is milk—butterfat (particles of oil) is suspended in water. Egg yolk is also a natural emulsion. Even before water

is added to the yolk to make medium, oil particles of the yolk float in water. Now, oil is a non-drying substance and water a quick-drying substance. Combine the two and you have a powerful binder, one that both dries to the touch in seconds and provides a tough, permanent, and virtually insoluble film when thoroughly dried. The complete drying process takes about a year and involves the denaturing of a protein. But for all practical purposes the film is water resistant within a few minutes and paint can be applied over it without disturbing it in the least.

Other Tempera Formulas

Some years ago I met an action painter who told me that many of his paintings fell apart after several years because he was using a chemically unsound method. I asked him how the owners of his paintings felt about this and he replied that he didn't care; only the momentary act of creating the painting was important.

Perhaps this is a valid concept, but I can't accept it. I *am* concerned about the durability of my paintings and that depends on the chemical reactions of the ingredients I use. Although I'm no purist in other respects, I do try to be as chemically pure as I can. So I reject formulas for tempera that contain impurities, such as agents that slow down the drying process, and stick to pure egg yolk and water.

Tempera formulas using the whole egg or egg white are chemically pure, but not as durable as medium made just from the yolk. An egg white medium and, to a lesser extent, a whole egg medium are less flexible and tend to crackle (a crackle is a flaw consisting of millions of tiny cracks that look like a spider web), while a straight egg yolk mixture is a little bit rubbery and has some give. The reason is that

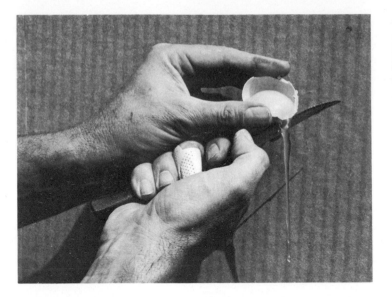

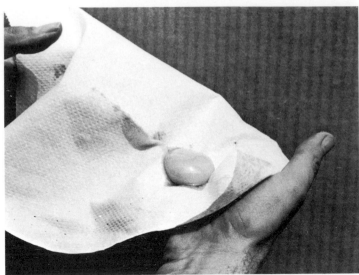

Figure 5. I crack the egg with a knife. If you have a different way for cracking eggs, do it, but be careful not to break the yolk sac. Then cut off the globs sticking to the yolk with a knife.

Figure 6. Eliminate white particles clinging to the yolk by shifting it back and forth on a piece of paper towel.

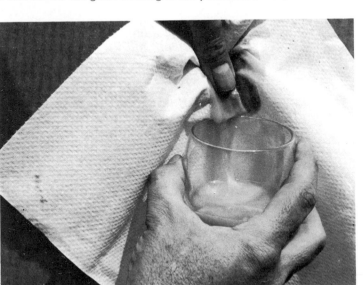

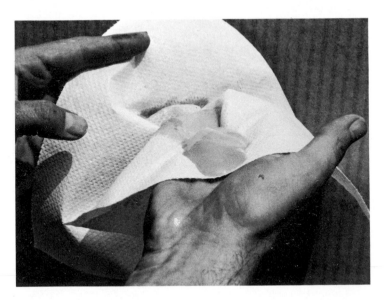

Figure 7. Slash the sac with a knife, squeeze the yolk into a glass, and throw the sac away. Then add a little water and stir.

Figure 8. If the yolk breaks while you're rolling it around or when you crack it, don't throw it away.

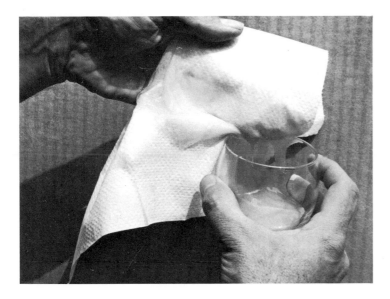

Figure 9. Pour the whole but broken egg into a glass, add a little water, and proceed with the next steps as you would if the sac hadn't broken.

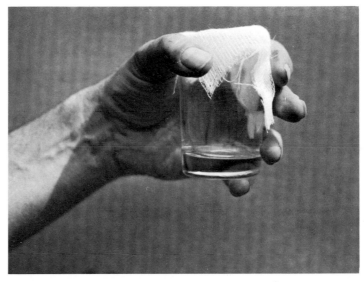

Figure 10. Place a piece of cheesecloth over the mouth of a second glass or jar and hold down the edges with your fingers.

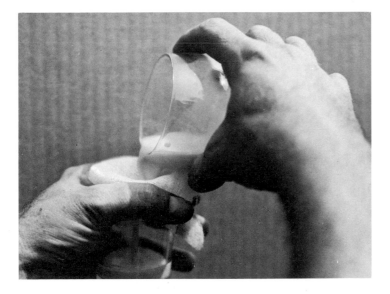

Figure 11. After tapping the cheesecloth in the middle to create a pocket, pour the egg-water mixture through.

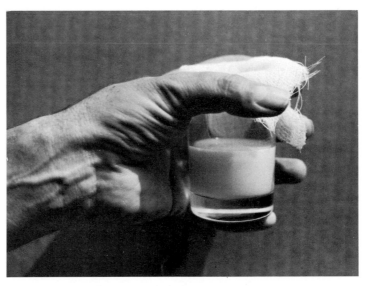

Figure 12. Cheesecloth strains out any lost particles of sac, egg yolk fat, and globs of white. What remains is your medium.

egg white isn't an emulsion because it contains no oil particles.

Numerous other emulsions can be used for tempera mediums besides egg: wax, gum arabic, oil, casein, and a host of synthetic compounds can be combined with water to create the necessary binder for the pigment. Some I've ex-

Figure 13. I'm about to mix titanium white and medium with a palette knife. It may take me several minutes to smooth out all the granules.

perimented with, others I've simply read about. None, however, seems to offer me any real advantage over medium made from egg yolk.

One last word before going on with how I mix up my egg tempera medium. Tempera techniques can vary just like formulas and some are just as dangerous. One painter I know alternates egg tempera with oil paint. First, he puts on a layer of tempera, next he covers it with oil paint and then he repeats the process. Each layer dries at a different rate, creating tremendous stresses that are bound to crack his paintings in the future. Perhaps, like the action painter, he doesn't care what happens to his work.

Medium Ingredients

Many artists have elevated the preparation of the egg tempera medium to the status of a ritual. The exact proportions of egg and water are supposed to be essential; the best ingredients—white eggs, never brown, and distilled water—are *de rigueur*; only the incantations are missing from the ceremony. My approach is more relaxed.

Eggs. I don't discriminate between brown and white eggs. Either will do; there's no reasonable basis for such a prejudice. I do prefer fresh eggs because they're easier to handle, but I've also used eggs several days or even a week old.

Water. Some painters prefer distilled water, but I've never felt the need for it. Tap water mixes just as well with egg yolk and I've never noticed the difference between a painting done with distilled water and one with water out of the faucet. But I'm not rigid on this point. Distilled water may be necessary in the future, even now in some areas. Cities are adding more and more chemicals to the water, and these impurities might bring about a chemical breakdown of the paint in a hundred years or so. If I lived in New York City, for example, where water is treated with fluoride, I guess I'd switch. As long as I live in the country, however, I have no plans to change. Retorts filled with distilled water, measuring cups, and the like make an artist's studio look like a chemist's laboratory.

Mixing the Medium

If I plan to apply an initial wash to a big panel, I might mix up several eggs at a time, but usually two jumbo eggs are sufficient for a day's painting. Not always, though, because the size of yolks varies. Yolks seem smaller on Cape Cod, larger in New York City. One egg in Manhattan might be worth three on Cape Cod. So common sense rather than a prescription determines how many eggs you need for your medium.

Step 1. Crack the eggs. I use a knife to break the shell and to cut off the little white globs that adhere to the yolk. But if you're a cook you probably have your own way of cracking eggs, so do whatever seems easiest to you.

Step 2. Shift the yolk, which is enclosed in a sac, back and forth between the half shells to eliminate the white. The trick is to prevent the yolk sac from breaking and mixing with the egg white. And here's where freshness counts. The sac of an old egg is weak. When I lived in New York City my studio had no refrigerator and I wasn't able to keep eggs fresh. I'd buy a half-dozen eggs at a time and they'd be all right for a few days, but the last couple of egg sacs would always break.

Step 3. If the sac doesn't break, put the yolk on a paper towel on a flat surface and roll it around, allowing the towel to absorb any white still clinging to the sac.

Step 4. Slide the yolk to the edge of the paper, slash the sac with a palette knife, and squeeze the yolk into a glass. Throw the sac and other material clinging to it away.

Step 5. Add water. How much depends on the yolk. As any cook knows, the consistency of egg yolks varies enormously. Some yolks are so thick they can scarcely ooze out of their sacs; others are almost as runny as water. The consistency of the egg–water mixture, or medium, should be a little thicker than light cream, but a little thinner than heavy cream. If the yolk is thick, add a lot of water; if it's runny, almost none. Use your finger as a stirrer to get the feel of the yolk and your head to judge how much water you need. Some people say there is a definite proportion—three parts egg to one part water, for example—but this isn't so. It differs from egg to egg.

Step 6. Stir the egg–water mixture with your finger or a spoon. Place a small piece of cheesecloth (I cut up a whole batch of 4″ x 5″ 's at a time) over a second glass or jar. Hold the cloth down on all sides, tap it in the middle to create a little pocket, and strain the mixture from the first glass into the second container. The glass or jar should have a narrow circumference so less of the mixture's surface is exposed to air. (Here again baby jars make ideal containers.) Any remaining particles of sac, egg yolk fat, or globs of white will be caught by the cloth while the yolks and water pass through.

Straining eliminates egg waste. Many painters think that if the yolk breaks before impurities are removed they must throw the egg out and start over. Not so. You could actually start with this step. Instead of first separating the yolk from the white, you could strain the whole egg through the cheesecloth. Some of the yolk would be lost because the white forms a slime, preventing all the yolk from getting through. So, although it isn't advisable, it can be done.

Step 7. Store the medium in the refrigerator if you want to save it overnight. Some authors recommend adding preservatives to the medium. Acetic acid, oil of cloves, and sodium benzoate have been suggested to preserve the medium. I can't see the need for this. If you plan to spend any time at all painting you'll use your medium in one day, two at the most, and it keeps perfectly fresh in the refrigerator. So what's the point in adding a preservative which might affect the painting in the future? Eventually all preservatives cause trouble.

Mixing Pigments with Medium

This procedure is sometimes called "tempering" but *The Random House Dictionary of the English Language* lists this as the sixteenth definition of the verb "to temper." So I'll refer to it simply as mixing pigments with medium to avoid questionable use of the word.

Brick Garden, 30″ x 40″. This is a spoof on certain aspects of modern art. The painted-on painting on the left represents pop art; the real vase and fake flowers, super realism; the vines and flowers on the wall, op art. The whole painting asks the question: What is real and what is unreal? Collection, Mr. and Mrs. John Mead.

The Last Look, 24″ x 18″. My vacant house provided the perfect background for this painting, as well as for The Apple Eater. Collection, Mr. Robert Breckinridge.

Scott, 22″ x 16″. My older son Scott posed for this painting. The fur on his collar was underpainted by stippling in dark tones and highlighted by painting in lighter tones with a brush. Collection, Dr. Thomas A. Mathews.

Key to the Universe. 24″ x 36″. An attempt to portray man's inability to render the infinity of the universe—expressed in a two-dimensional wall painting. Collection, Joslyn Art Museum, Omaha.

Military Clown, 24¼″ x 20¾″. *Photographs of Prussian generals with their enormous mustaches inspired this clown painting. Notice the target placed over the clown's heart. Collection, Mr. Herbert Adler.*

paintings such as *Under the Seesaws* is its abstract design; the figures are incidental. I wanted to see if I could integrate a great number of dissecting lines and curves into one good design. So I set out to find a concrete image to illustrate a geometrical pattern. The seesaws provided an excellent vehicle but it took years to solve the problems involved in working out a design.

Visual Stimulation. Underlying most painting is direct observation. Mundane scenes like a child drawing on a sidewalk, or a pile of discarded dolls spark my imagination. Even the ideas for such abstract paintings as my bicycle scenes were first planted as I watched my children throw their bicycles on the porch. Studying their elongated curves and lines created by the shadows of spokes and wheels, I realized their patterns formed exciting designs. Today I consider them among my best paintings from an abstract point of view, but the visual image rather than a desire to conquer a design problem inspired the work.

Philosophical Ideas. Artists occasionally start with abstract ideas and then seek to express them visually. They feel compelled to vent their political, social, or religious beliefs through art. But my feeling is that painting isn't the medium to express this kind of idea. All too often intellect takes precedence over aesthetics and a mediocre painting results, rendering a disservice to both the painter's art and his belief.

It can be done, of course. There's no denying that many figurative paintings contain a strong social comment. Take the great Mexican murals for example. Violent rejections of society explode in the viewer's face, but they're secondary to the painterly elements of line and color. In my own work I almost always avoid a direct comment, searching instead for a mood to describe the human condition in the modern world. For example, in *The Corner Seat*, loneliness and alienation permeate the scene; in *Under the Swings* menace hovers about the figures; in the *Bell Chain* corruption surrounds even the spiritually pure. Color, design, and texture created these moods or ambiences rather than the narrative element of the picture.

Once in a while I break my own rules, however, and *The Monument* is an example of such a departure. Here

my own political feelings came through. While the painting means different things to people who don't know its background, I admit it's a war protest, painted at the height of the Vietnam War.

Combinations. A painter's font of inspiration isn't an orderly flow—ideas combine with others to generate new ones. I just said that a political idea preceded *The Monument*, but so did a desire to paint a monochrome blue picture; which came first, I don't know. Other paintings are conceived in the same way. The *Bell Chain*, for example, sprang from several sources: a textural experiment, a remembered scene, and a desire to evoke a mood. So asking a painter where he got an idea is a little like asking which came first, the chicken or the egg.

Wait-and-See. I'm not always successful in capturing my ideas on a panel. Right now a kernel of an idea is pestering me but the image isn't clear enough for me to make even a satisfactory sketch. I'll tell you what I mean.

At a parade interrupted by a sudden downpour, I saw a group of people huddled together wearing transparent raincoats which they had pulled up to cover their heads. The plastic of the raincoats pressed around the people, flattening their skin; they looked like fetuses enclosed in wombs. My mind transformed the scene into a metaphor of frightened people unable to free themselves from frightening surroundings. They clutch their garments for protection, but you can see right through them and observe how vulnerable and how afraid of life they are. But the scene remains locked in my head; the image is too obscure so I'll have to wait and see how it develops.

Implementing the Original Idea

Before plunging ahead with an idea, some consideration must be given to visual aids, such as props and models, which help the painter implement his original idea.

Photographs. I take scores of pictures of people and objects but rarely paint from them. Instead they act as spurs to my imagination, giving me an overall sense or feeling of how I

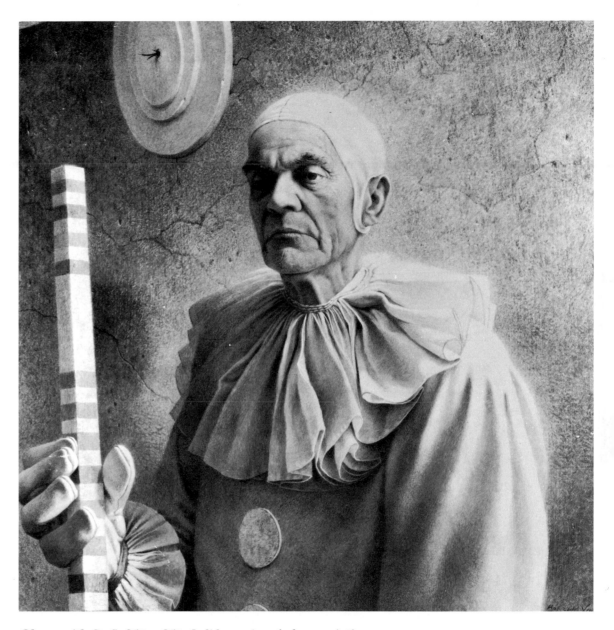

Clown with Staff, 25" x 25". *I did a series of clown paintings over a period of about ten years. The model for this one appears in several of them, as well as in The Birdman. Collection, Mr. and Mrs. Louis Regenstein.*

Sean Holding Gerbil, 28¾″ x 23″. India ink on paper. An example of a finished pen and ink drawing. Courtesy, Midtown Galleries.

The Scythe, 30″ x 35¾″. India ink on paper. My children are growing up faster than I can paint them, so I'm now doing detailed drawings of them for future use. Collection, Mr. Gerald Lieberman.

The Swings, 41″ x 31″. The mood here is loneliness and alienation: the children play together, yet they are isolated. I was also trying to depict three aspects of my own children's personalities. The lower boy is relaxed and enjoying himself; the girl is intense; the top figure is oblivious to everything, way off in the blue. Private collection.

Wooden Horses, 31″ x 41½″. Merry-go-round horses offer an opportunity to question the reality or unreality of the world. The shadows of the horses look real, the bodies do not. Notice how the floor has been drybrushed and scratched with a razor blade. Collection, Canajoharie Library and Art Gallery, Canajoharie, New York.

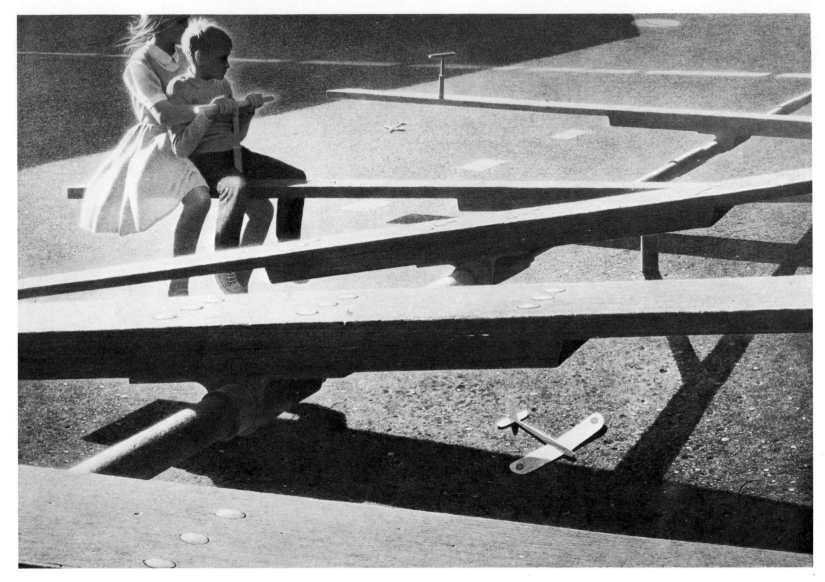

Gliders (Above), 31″ x 45″. The children here may be trying to fly away to another world. The angles of the seesaws create the image of wings, intensifying the illusion of flight. Collection, Mr. and Mrs. Stephen Owen.

The Monument (Right), 35⅞″ x 48″. My own personal feelings about the Vietnam war are expressed in this painting. A statue, representing the military to me, had been transformed by canvas draperies: no longer a symbol of heroism and nobility, it had become a menacing, raging beast of war. The image is obscure enough, however, so the painting means different things to different people. Courtesy, Midtown Galleries.

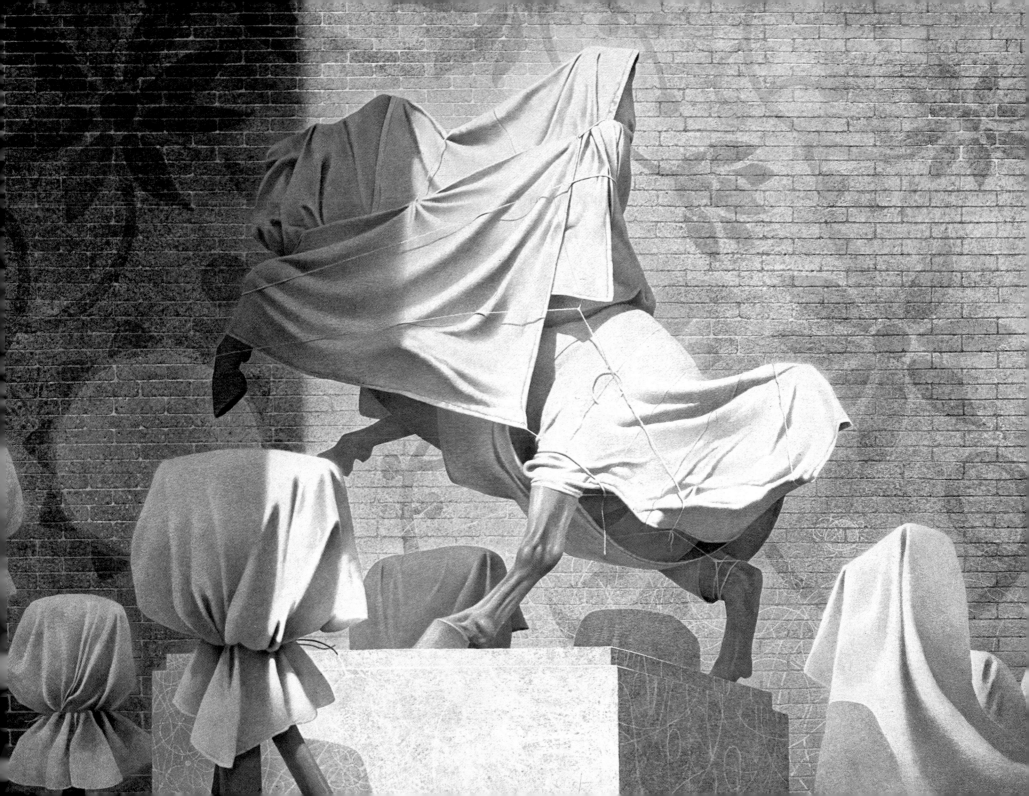

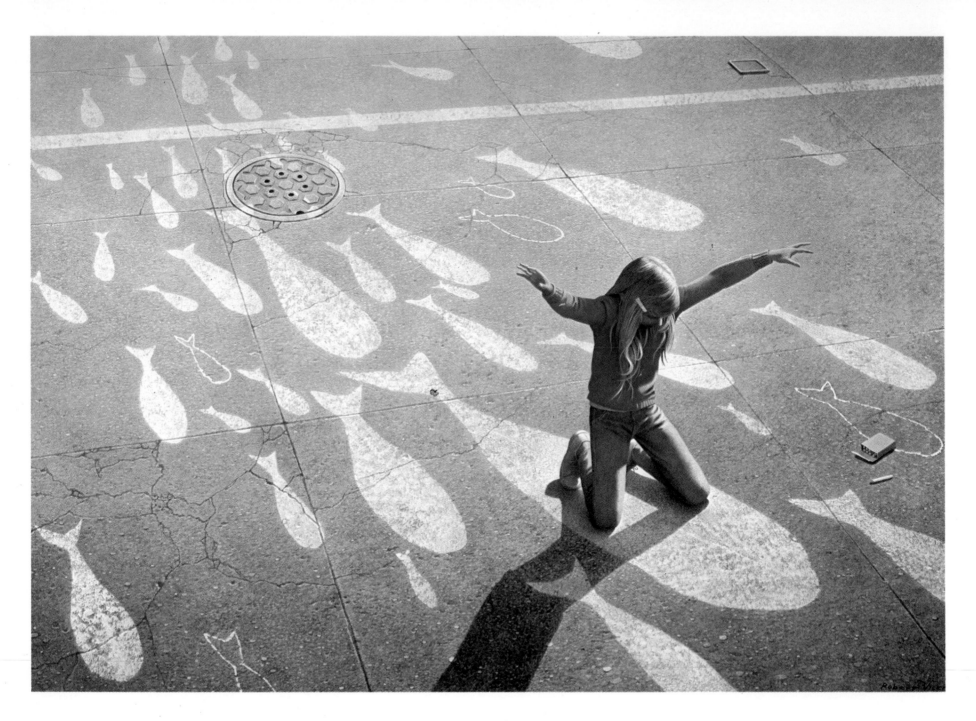

Fish Ride (Left), 29″ x 42″. A favorite theme of mine is the liberation of children. I like to think of them skimming over the ocean or flying through the air, released from the restrictions of the world. Private Collection.

The Parakeet (Right), 26″ x 38⅛″. I covered the entire painting with acetate and painted the pattern of the rug on it in light gray watercolor. When I got the design I wanted, I lifted up the acetate and painted it in with small strokes to look like stitches. Collection, Mrs. Benjamin Friedman.

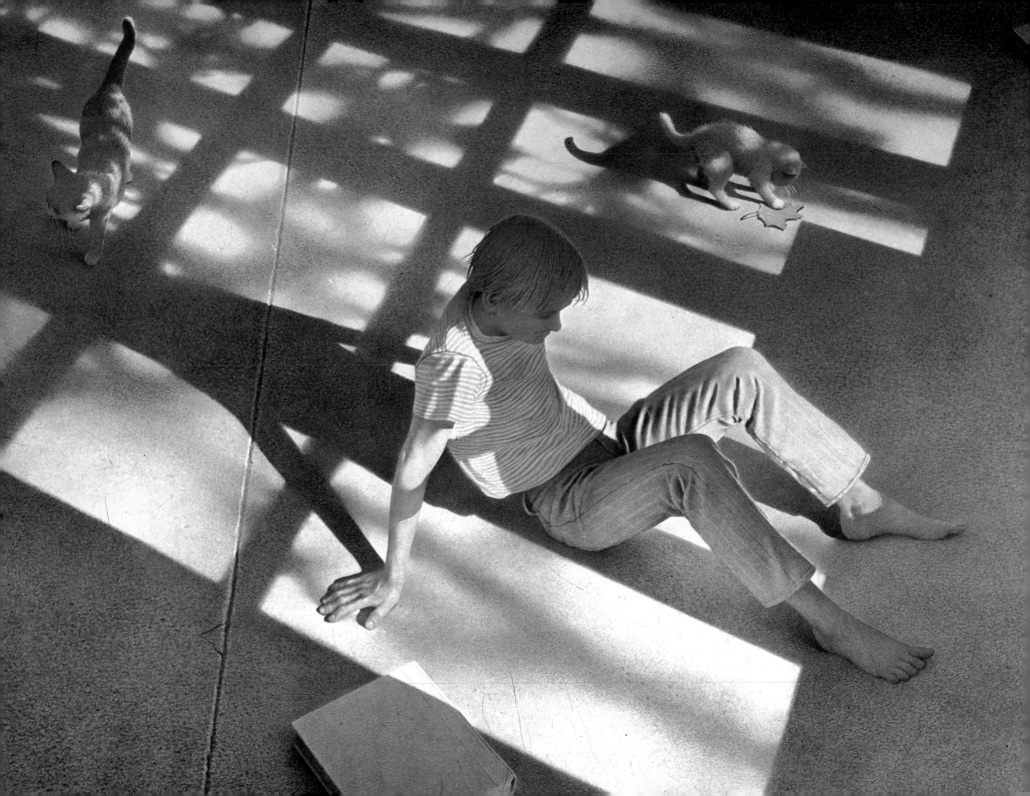

In The Boat House (Left), 33¾″ x 43¾″. This is egg tempera at its most luminescent. I've always admired the way Turner used light. His paintings vibrate with shimmering tones that fill the atmosphere with a glowing quality. In this painting I feel I've come close to his approach to light. Notice, in particular, how the square in the left middle shimmers with color. Courtesy, Midtown Galleries.

Street Scene (Above), 26″ x 40″. Very deep tones are better achieved with oils. Still, as you can see in this painting, egg tempera can produce colors that are lovely and rich. Collection, Midtown Galleries.

Bird Sounds (Left), 30" x 20". *The painting has an overall cool bluish tonality despite the bright yellow scarf. To get the textural effect of the sweater, I underpainted with a very light tone and glazed it down quite dark. Courtesy, Midtown Galleries.*

March Wind (Right), 24" x 36". *Here's a good example of wall texture. Nearly every color on my palette sparkles on this old wall. The girl, one of my favorite models, is being pursued by bird-like or winged shapes. Perhaps they're the cares of the future —or perhaps they're simply old posters. Collection, Mrs. Nathan Allen.*

Plastic Umbrella (Left), 22¼" x 16¼". This painting (the completed version of Demonstration No. 4), was done in cool colors. Lots of viridian, burnt umber, and ochre make up the shadows of the tree on the left side. Collection, Mrs. Martin C. Barell.

Golden Gliders (Right), 17" x 24⅛". The completed version of Demonstration No. 5. This is the warmest picture I've ever done. Yet, despite the temperature of the overall painting created by lots of yellows and reds, notice how the dark bluish gray underpainting still comes through on the right side. Courtesy, Midtown Galleries.

Newborn Kitten (Left), 36" x 24". Here's another attempt to produce fantastically subtle, Turneresque lighting effects. Cobalt blue, burnt umber, cadmium yellow, yellow ochre, viridian, and cadmium red—nearly every color on my palette—have been stippled, splattered, and sponged on the wall, and they all sparkle through. Courtesy, Midtown Galleries.

The Cat (Right), 36" x 48⅛". When I started this painting, I picked a large panel because I didn't know how big the final painting would be. It grew out to the edges; if it hadn't, I would have sawed off the panel. Collection, Mr. and Mrs. Irving J. Bader.

No Hands (Left), 29¾" x 17¾". I tried to create the illusion of a circus tightrope rider in this painting of my daughter Carri. The illusion is heightened by the line in the street which might represent a tightrope. Courtesy, Midtown Galleries.

Five Shadows and a Line (Right), 26" x 38". I was inspired to paint bicycles after I noticed the shadows of my children's bikes as they lay on the ground. Courtesy, Midtown Galleries.

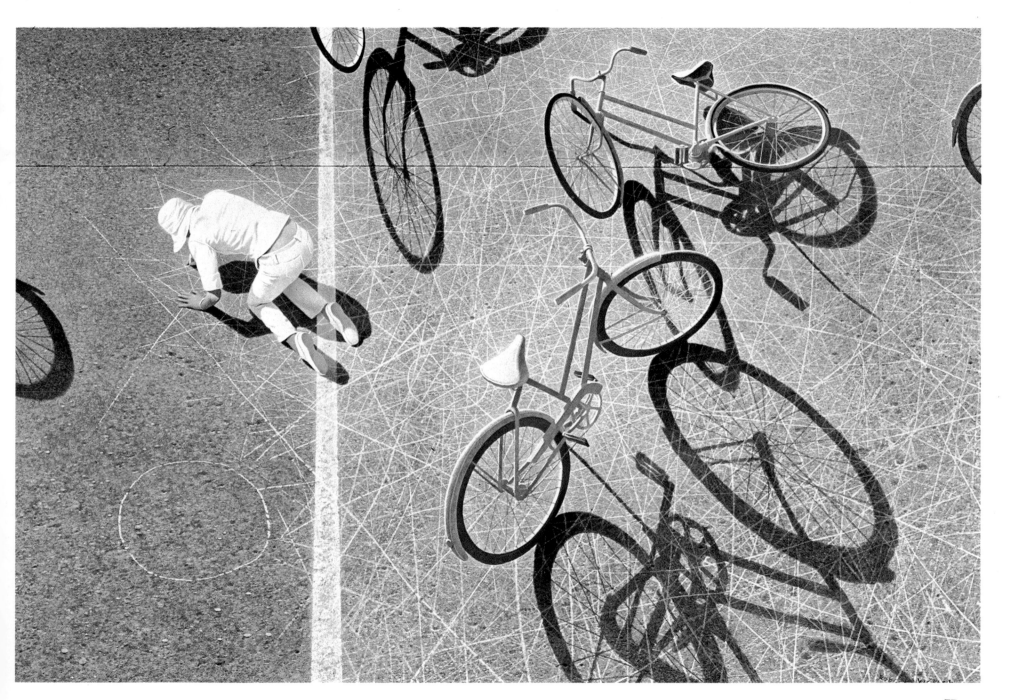

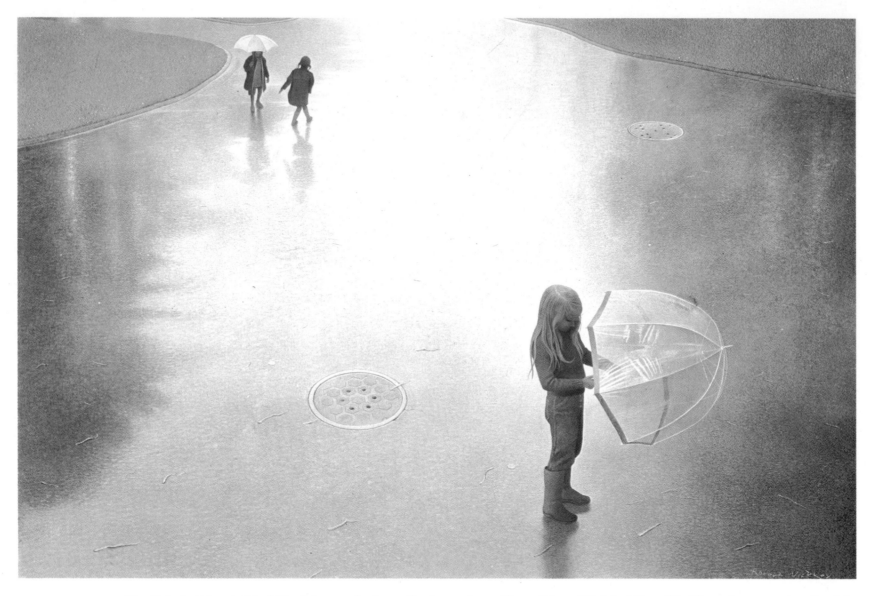

The Drizzle (Above), 24″ x 36″. I frequently do small color studies using different techniques. One day while randomly splattering paint on a panel, I noticed that the colors reminded me of reflections on wet pavement. I started a larger panel, and the result was the painting reproduced here. Collection, Mr. and Mrs. S. Lewis Hutcheson.

Lines, Lines (Right), 30″ x 40″. The safety zone is echoed by lines and curves of the drawings on the pavement. Many of the chalk drawings, which were drybrushed on, contain tiny figures and jokes. Courtesy, Midtown Galleries.

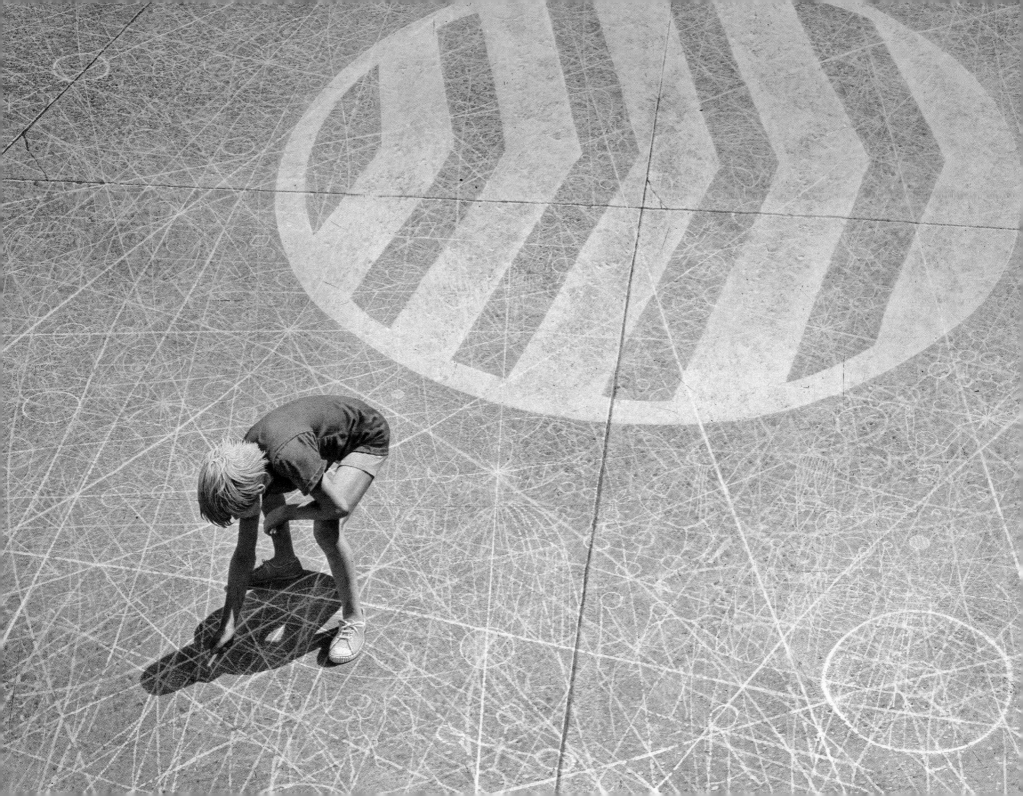

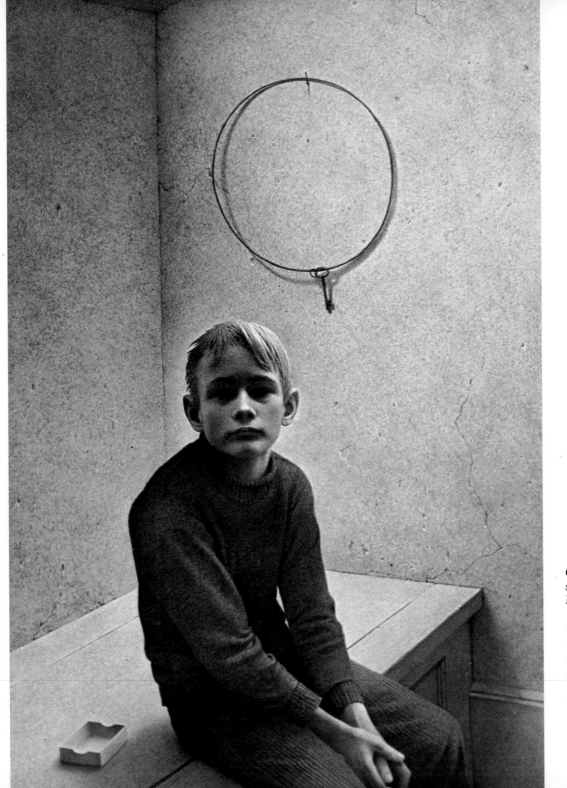

Corner Seat (Left), 24″ x 36″. *Every color on my palette is represented in the underpainting of this picture. Collection, Mrs. Robert Vickrey.*

The Magic Carpet (Right), 24″ x 36″. *Some critics feel a three-dimensional quality is best rendered by oil painters, but this example shows how completely three-dimensional an egg tempera painting can be. The figure moves in and out of the light which clearly establishes her in space. Collection, Mr. Herbert Allen.*

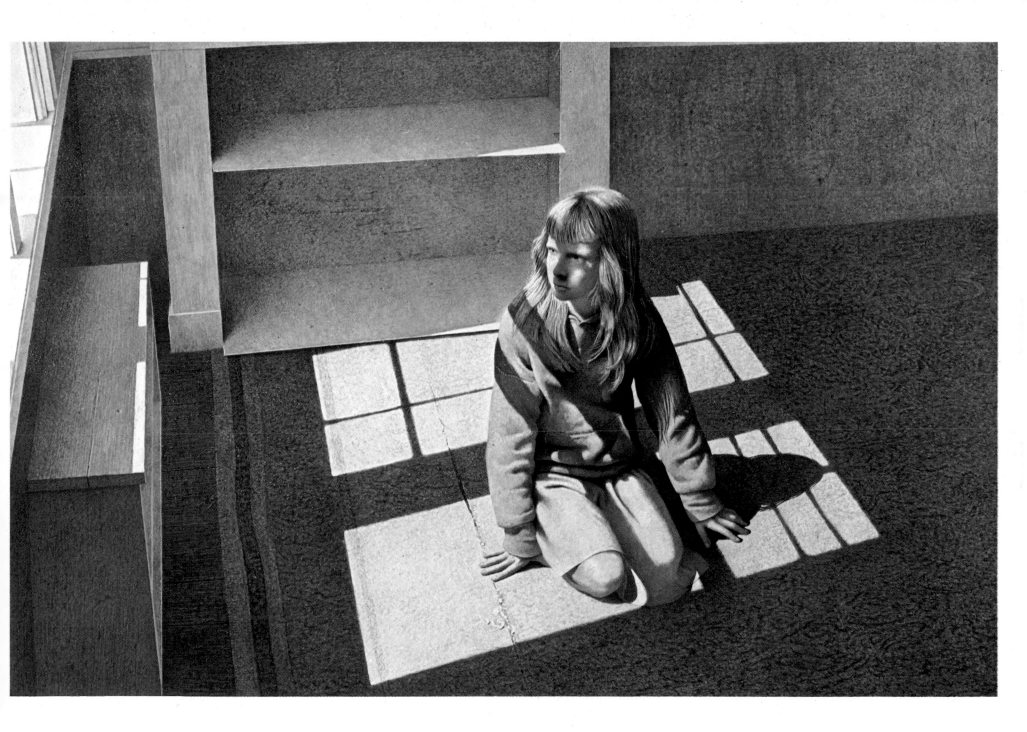

Robert DeGrey

Bicycles (Left), 32" x 46". This is one of my earliest and most difficult bicycle paintings. It took me eight years to relate all the wheels and shadows. Collection, Mr. and Mrs. F. Richards Ford.

Lengthening Shadows (Above), 14¼" x 22¼". The effect of late afternoon sun on pavement was created by glazing the entire panel with a warm brownish ochre glaze over a much cooler underpainting. Courtesy, Midtown Galleries.

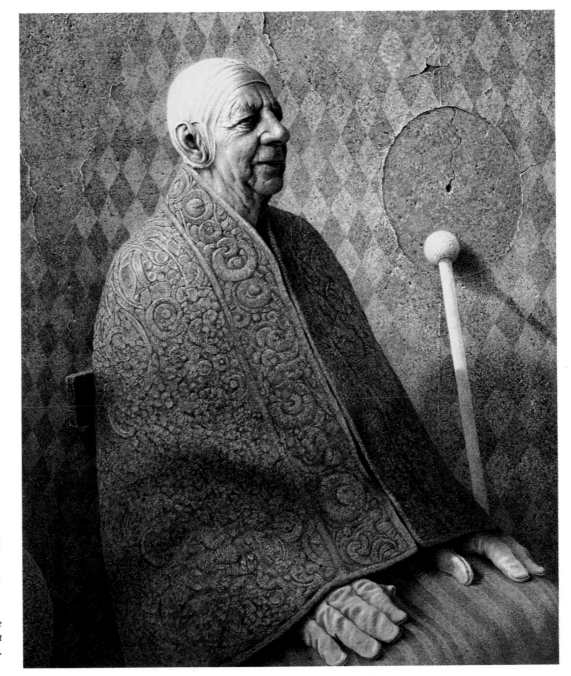

Crossings (Left), 20″ x 30″. *I stippled the nuns' robes with a mixture of cobalt blue and a little ultramarine and then glazed them down. If I'd worked in the reverse manner—painting the robes darker and scumbling lighter—I'd have killed the beautiful blue tone. Courtesy, Midtown Galleries.*

Clown in Gold Cape (Right), 30″ x 24″. *Satire is my purpose here. The ceremonial figure clad in a lavish gold cape sits on a rotting chair against a crumbling wall. Collection, Mr. and Mrs. Norton S. Walbridge.*

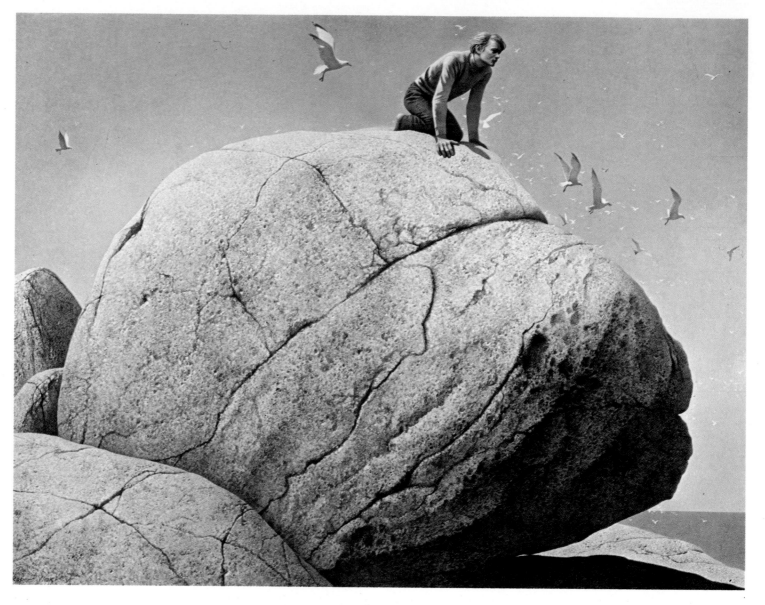

Baskerville Rock (Above), 31½″ x 40⅜″. *The completed version of the painting in Demonstration 3. Courtesy, Midtown Galleries.*

The Birdman (Right), 36″ x 48⅛″. *The completed version of the painting in Demonstration 1. Courtesy, Midtown Galleries.*

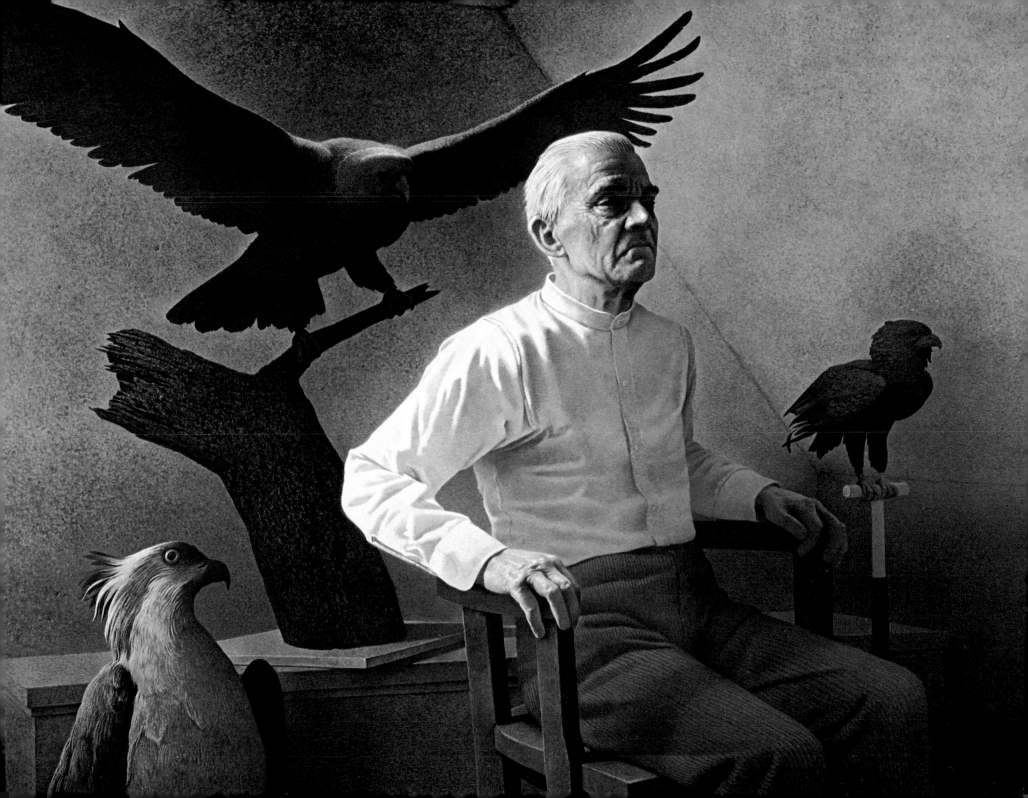

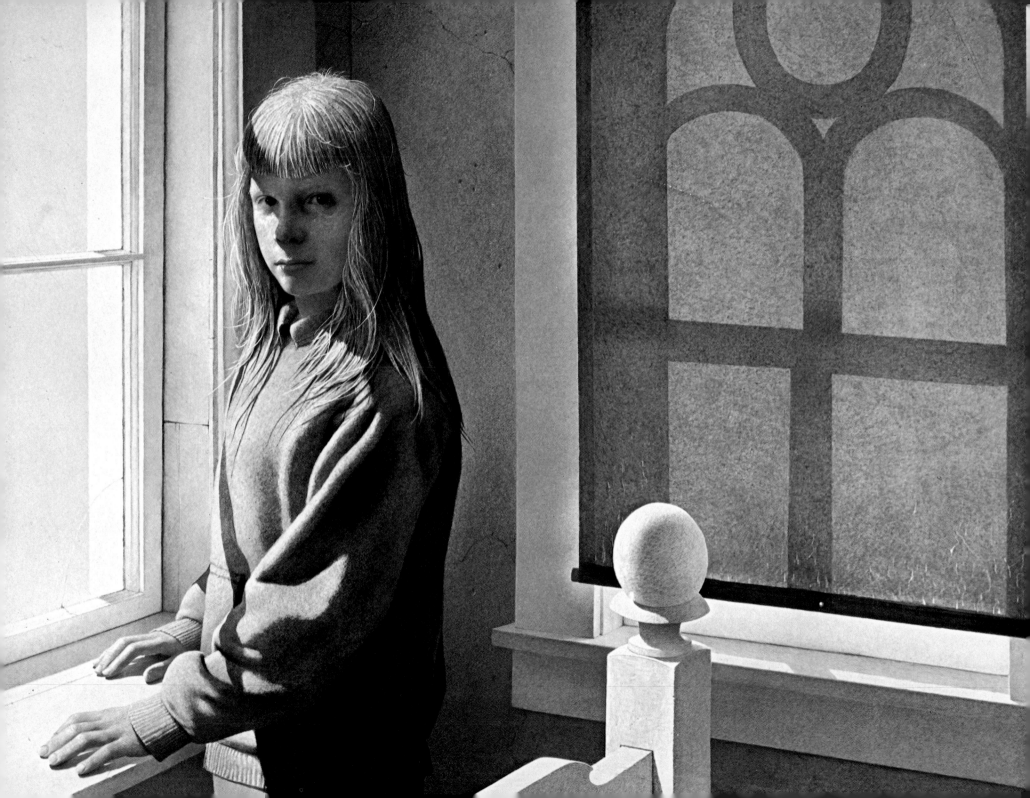

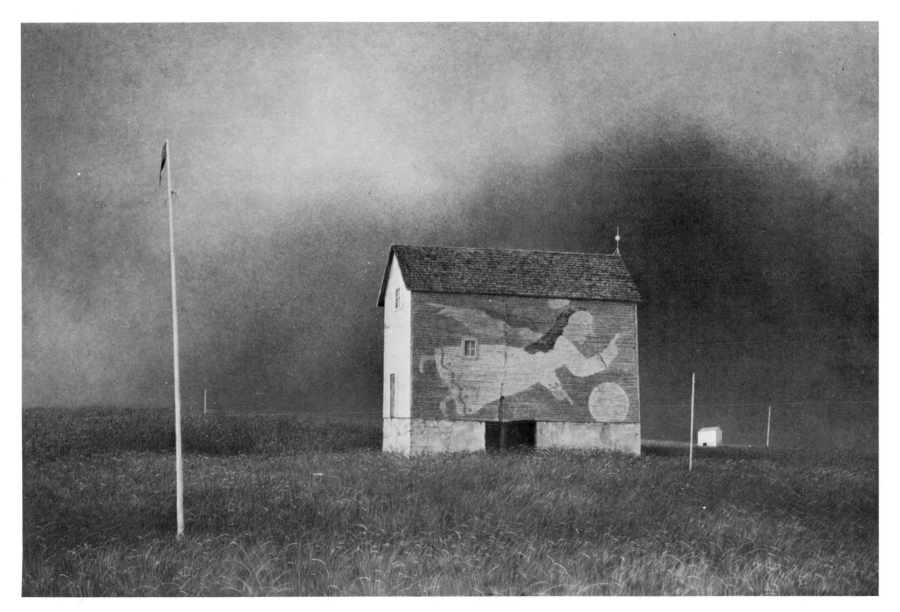

Corner Bedroom (Left), 28¾″ x 35¼″. More repeated forms: the head and shoulders echo the bedpost and the shadows on the window shade. Collection, The Metropolitan Museum of Art, New York. Gift of Mr. Richard Shields.

Hovering Angel (Above), 24″ x 36″. One wonders who is protecting the barn. The angel who points to heaven and earth or the lightning rod? Judging from the crack down the center of the building, neither is doing a very good job. Collection, Mr. Malcolm Forbes.

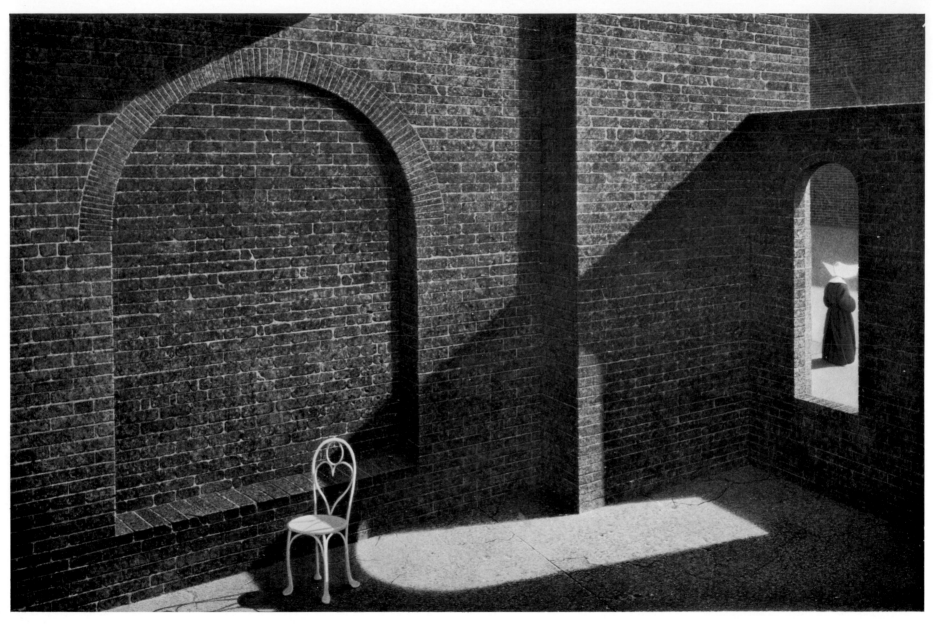

The White Chair, 20″ x 30″. This is practically an abstract painting—only the arches and their echoes are important. Collection, Mrs. Nathan Allen.

7. Composing a Painting

With few exceptions, I dive right into a painting by composing on the panel, foregoing preliminary drawings both on paper and panel. Naturally the composition is pretty clear in my mind. If a particular problem does require a preliminary drawing I work on it only until I reach a generally satisfactory solution. In other words, I keep it simple. Any compositional wrinkles that remain I iron out as I paint.

This approach allows me to paint freely and spontaneously, and represents the essential difference between classical egg tempera painters and painters who work as I do. Classical painters follow an ironbound rule of first transferring an elaborate cartoon onto the panel and then redrawing it in India ink. Sketching with a brush, experimenting, innovating, and improvising are dirty words to them. They believe that the medium is unsuited for unconsidered work, that only highly developed designs drawn down to the last blade of grass can ensure a good performance.

I don't know about the good performance, but this method certainly ensures rigidity. I know this from watching students. The students with previous experience in the medium inevitably turn out to be the most skilled draftsmen. And I expect them to produce the best results.

Not so. They carefully draw their design on a panel but then they don't know what to do. They're scared stiff of ruining their initial design by boldly changing and improving it with paint, so they end up tinting their drawings rather than painting. This isn't always a disaster—Reginald Marsh was a master at wash drawings.

Drawing on Paper

To repeat, I hate to do a preliminary drawing on paper because I dislike duplicating my efforts on the panel. Neverthe-

less I sometimes do it, particularly with paintings based on complicated abstract designs such as *Under the Seesaws*. I subjected this painting to as many, if not more, steps than a medieval painting. First I drew on toned paper. It was pretty good, but not what I wanted. Next I made a more elaborate sketch on tracing paper. A small portion of it satisfied me so I cut that out, traced it on a new piece of paper, and redesigned the other elements. I repeated this salvaging-and-redesigning process dozens of times until I worked out a pleasing design that, while still crude, sufficed to get me started on panel.

Drawing on Panel

As a general rule, when the touchstone of a painting is the relationship of shapes, I plan on paper first and then draw on the panel in pencil. I never draw with charcoal, the generally recommended medium. A charcoal drawing can easily be wiped off or blown off, leaving only a blurred outline. To prevent this the drawing should be sprayed with a fixative like varnish, but you can't cover this substance with egg tempera. So I never use charcoal.

And I never use India ink on a panel. This ink should be avoided like the plague if you want to allow yourself any freedom at all. Once you've put a drawing in with ink you're totally committed to that one design. There's no going back unless you scrape off all the paint and the ink too. And scraping off a complicated design is a very difficult job.

Drawing on Panel with Brush

I like to start right in on the panel with brushes. In most of my work there's a painting problem, as opposed to a com-

The Longest Shadow, 30" x 20". The child is playing Jack Pumpkinhead. By drawing a face on the manhole and buttons on the pavement, he has created an instant puppet. Collection, Mr. and Mrs. Francis Rosenbaum.

positional problem, that I must master before I decide to go ahead with the picture—the main figure, for example, or the texture of a rock, or the overall tonality. Furthermore, I like to let a painting grow by itself. And to make sure I have plenty of space to work in I use very large panels. Then if the painting expands, I work out to the edges; if it doesn't I cut the panel down to size with a saw.

Occasionally I plunge right onto a panel even with a complicated design. A good example of this dive-right-in approach is *Bicycles.* I brooded over the composition of this painting for eight years, making sketch after sketch. But the interlocking shadows of the wheels were so complex I failed to produce a drawing I liked. Nothing worked. Finally I threw caution to the winds and began on the panel. Success, at last.

Drawing on Cellophane

If the main element of a panel works, I go on with the composition. And Protectoid, an acetate that looks like clear, heavy cellophane, expedites this job. Different parts of the painting can be drawn with a brush on this marvelous material which sticks to almost any surface including gesso panel by static electricity and is so stable you can paint on it. I simply place a piece where I think it might jell with the other elements of the painting.

Here's how it works. Taking *In the Boat House* as an example, pretend that the cats aren't in the picture. The boy has been drawn to my satisfaction, but I'm not quite sure where the cats should be put. Instead of trying out various locations and positions by penciling them in (and then having to overcome pencil lines) or painting (and scraping them out if I don't like the arrangement), I paint the animals on pieces of acetate and attach them to the panel by static. When I find the arrangement I like best, I tape the top of the acetate to the panel, lift up the bottom of it and paint the cats in directly underneath. What could be easier or safer?

Composition

Telling someone how to compose a painting is a little like telling an actor how to comb his hair. It's too personal, and

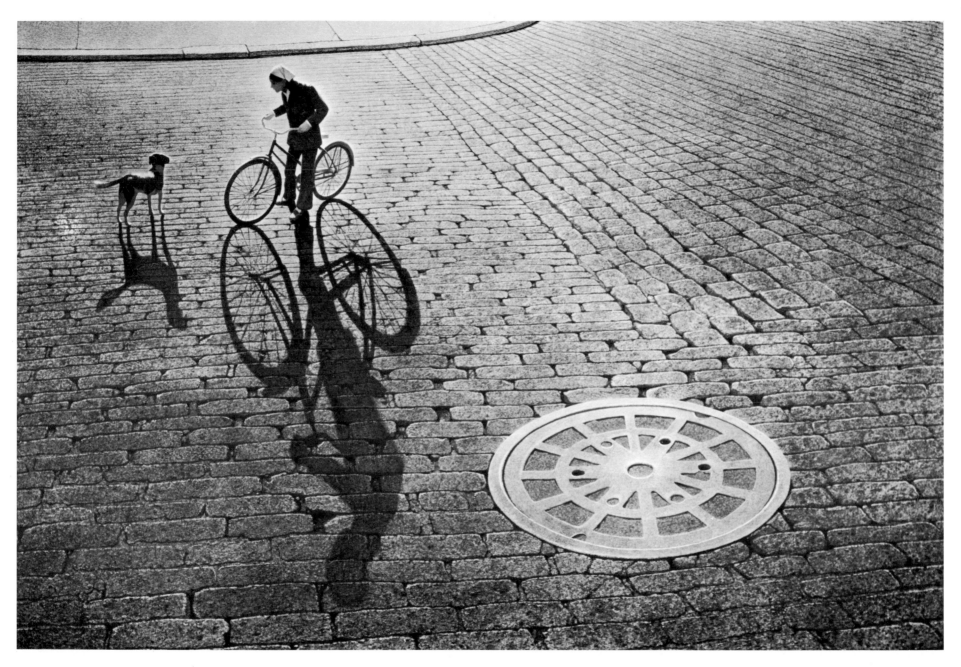

Carri and Cocoa, 23½" x 35¼". A study in curves intersected by lines. Courtesy, Midtown Galleries.

liable to be wrong. There are no restrictions that can't be contradicted by some masterpiece. Many teachers, for example, caution students against placing a figure in the absolute center of a painting and this sounds reasonable: a focal point right smack in the middle is less interesting, it seems to me, than one placed off-center. Yet those gorgeous Byzantine icons stare out at the viewer from the dead center.

Still people have a habit of making rules and as a result they frequently hamper creative development. Recently, for instance, I heard about a painter who forbids his students to use diagonals. Such absurd dogmatism reminds me of the famous art critic who declared that he liked Adolph Gottlieb, the abstract artist, and then went on to say that if he admired the work of a painter like Gottlieb, he couldn't like the work of a painter like Andrew Wyeth. It was impossible for him to appreciate both abstract and realistic art at the same time. So, he couldn't give a favorable reveiw to a realistic painter. The teacher is being equally absurd by refusing to recognize a compositional device that he doesn't like and penalizing his students if they do. Both critic and teacher strait-jacket up-and-coming artists by forcing them into certain molds. Painters should have the freedom to try out all styles and techniques and, after completing their research, decide on what they feel comfortable with.

I can tell you what compositional arrangements I'm com-fortable with. Most of my designs are arranged asymmetrically with one main area of interest balanced by another. In *Pulse*, the shadowy boy is way off-center, but he's anchored firmly in the picture by the dark line of the bed post. In *Dream Dance*, the small, dark, dream-like image of the dancing child is as strong as the large real girl. Sometimes I like small solid areas to support large insubstantial ones as in *The Longest Shadow*.

Another favorite device of mine is to play off two dichotomous elements, such as diagonals against lines or curves against lines, and then repeat these themes throughout to develop echoes of the central motif. In *Carri and Cocoa*, for example, the vertical and horizontal lines of the street bricks confront the curves of the manhole, the wheels and their shadows, the dog's shadow and the curb. The *Corner Bedroom* also contains repeated geometrical patterns. The rounded forms of the shadows, the bed post, and the girl's head counteract harsh vertical lines. In *Lines, Lines*, I carried this device one step further by juxtaposing a painted line next to a three-dimensional one (the expansion joint in the pavement).

As I said, however, these are my ways of using composition to express myself. If they work for you, good; if not, there are thousands of other possibilities.

Pulse, 30″ x 40″. *The dark bedpost firmly anchors the boy in this picture. Collection, Randolph-Macon Woman's College, Lynchburg, Virginia.*

The Spider, 20″ x 30″. The entire background of this picture was scumbled. The free-standing leaves were glazed with light gray, while those that touch the curtain were painted with a transparent darker gray. The bottles, containing colored liquids, were glazed with different colors and highlights were scumbled in. Collection, The Brooklyn Museum, New York. Gift of Mr. Richard Shields.

8. Applying Paint

I once knew an egg tempera painter who didn't believe in painting. He thought a perfect work of art could be fashioned by making a detailed drawing and then turning it over to a skilled draftsman for rendering. He couldn't accept the idea that painting gives life to a work of art. He couldn't understand the joy of finding a pleasing color combination by accident; of seeing a hoped-for result succeed; of making beautiful colors even more beautiful. To put it another way, he didn't know what painting, at least painting in egg tempera, was all about.

Yet it's hard to see why he didn't. The glowing optical effects produced by thin layers of egg tempera are fantastic—and obvious. They're not so apparent in color reproductions, however, for no matter how well a magazine or book reproduces an egg tempera painting, the process diminishes the luminescent quality and jewellike tones of the paint.

Let me explain again how these effects are produced. With the exception of the most concentrated white pigment, which is almost completely opaque, most egg tempera pigments range from transparent to semi-opaque. Even when white is added to other colors they never become completely opaque. So if you apply a translucent (semi-transparent) coat of paint over a dried coat of semi-opaque color, the first color will show through the second and create another color different from the first two. In other words, the colors in each layer blend visually, not physically, because each layer is applied over a dried coat of paint. The result is paint that vibrates with color.

In my work I strive for an overall tone or color scheme that unifies a painting. That is, my paintings have a limited range of color with one color usually predominating. *Bird Sounds*, for example, is more or less blue; *Lengthening Shadows*, more or less brown. But these overall tonalities contain many other shades. I underpainted the seemingly brown pavement in *Lengthening Shadows* with blues, greens, and reds. The colors then work together to produce a single color. Yet on close inspection the colors underneath still shimmer through the final brownish tone.

Achieving these effects is quite easy. It's simply a matter of applying an initial wash, then an underpainting, and finally an overpainting. The first two steps contain contrasting colors to set up the crude beginnings of a harmony that will result in an overall tonality. The third step softens and enriches the layers underneath. Let me explain in more detail.

Initial Wash

Some manuals advise priming the panel before you paint to seal the gesso so it will be less absorbent. I don't think that's necessary. An initial transparent wash seals the panel just as effectively. Of course, you don't have to lay in a wash. I do because I like to start the build-up of colors right off the bat, and an initial transparent wash gets me off to a good start.

Step 1. Set up your palette as described in Chapter 5 with the colors around the outside. Then pour medium in the middle of the palette to form a puddle.

Step 2. Select colors to create a wash. For the sake of example, let's pretend you choose a little ochre and umber, as I did when I began the *Corner Seat*.

Step 3. Take a large housepainter's brush if you're working on a large panel, or a smaller brush for a smaller panel. Drag the pigment into the middle of the palette and mix with the medium. Always make sure you add enough medium so that the paint adheres to the panel.

Step 4. Dilute the tempera with extra water.

Step 5. Place the panel either on an easel or a horizontal surface. The latter is a good idea if you're a beginner and can't control paint as well as a more experienced artist.

Step 6. Use broad, overlapping, horizontal strokes to apply the wash to the panel. Don't worry about laying in an even wash, however. Any streaks will soon be covered by many layers of paint.

Underpainting

The purpose of this step is to build up layers of solid color that will come through the overpainting strongly. By solid colors I mean colors that are nearly opaque. In my paintings I achieve opacity, or more correctly semi-opacity, by mixing colors with white. Not every layer of underpainting will contain white, but some will. To give you a concrete idea of the diverse color possibilities of underpainting, try a few of the combinations that I used as I painted the *Corner Seat.*

Step 1. After allowing your ochre-washed panel to dry, mix up a batch of cool gray. The gray, while more opaque, will have almost the same tonal value as the ochre wash. Put the gray on in unconnected strokes so the ochre comes through the gray. Now look at the sparkle and shine created by these two colors which are close to being color opposites.

Step 2. Next try some warm colors over the gray–ochre combination. By placing warm over cool, or vice versa, you create more excitement than you would if both colors had the same temperature. In this situation I used a combination of ochre, viridian, burnt umber, and a touch of cadmium red.

Step 3. On top of this layer scrub in a layer of nearly opaque light gray. Seen through this veil, the colors underneath are softened although they still shine through. Scrubbing with light paint over dark is also called *scumbling.* Scumbling can be done either in the underpainting, as it is here, or the overpainting, when the color is thinned down to appear translucent. When you scrub, be sure to use a brush you're not afraid of hurting; the vigorous motion may cause hairs to break off. If they do, brush them off the panel.

Step 4. Apply thin coats only. When I talk about scrubbing paint around I'm still talking about thin layers of paint. So if you get too much paint on, blot it with your hand or a piece of cheesecloth.

Step 5. Continue to apply layer after layer of underpainting. In any one painting I may underpaint as many as ten layers. And don't be afraid to experiment with wild combinations. In *Big Flower*, for example, I underpainted the rock with a mixture of ochre, cobalt blue, viridian green, and alizarin crimson and it worked.

Overpainting

Glazing and scumbling complete the optical effects of the painting by enriching the undercoats.

Glazes. You can glaze any color over any other color as long as it produces a combination that you like. There are no rules to guide you in your choice, although it's often advisable to glaze a warm color over a cool one, or vice versa. The reason for this is simple common sense: no significant difference can be seen if you apply one warm color over another warm shade. They look too similar.

The only other advice I have on the choice of glazes concerns values. Don't vary the values between glaze and underpainting too much—a big difference will make your painting look "jumpy." When I glaze I always mix up a color approximately one value darker than the color I plan to cover. For example, if the underpainting is the middle value of cobalt blue and I plan to glaze with ochre, I use a shade that's one value darker than the middle value of ochre. (This principle also applies to scumbles. Scumble usually only one value lighter than the value of the underpainting.)

Glazes should be applied with flat brushes, not brushes that come to a point, in a size suitable to the area you're working on. Most glazing is done in small areas: it's easier to handle runny, quick-drying paint if you don't glaze on a large scale. But it can be done. Occasionally I've glazed an entire painting. Here's how to do it:

Step 1. Make sure the underpainting has been dry for several days and then mix-up a puddle of paint. (Use sufficient medium—the most common mistake students make is failing to add enough.)

Step 2. Dilute with a fair amount of water.

Step 3. Paint a small area, say ¼" square, to see if the mixture complements the underpainting. If you're not satisfied, you have a few seconds to wipe the glaze off with cheesecloth before it dries.

Step 4. If the tone is right, take a fixative sprayer, fill it with water, and very lightly spray the whole area with a little film of water. Supposedly you can't glaze over large areas because the paint sets so quickly. But spraying water on the panel delays the drying process.

Step 5. With the surface slightly damp, take a large housepainter's brush and load it with lots of glaze.

Step 6. Glaze from top to bottom and left to right (or right to left if you are left-handed). Draw your brush across the panel so each stroke is one entire sweep across the area and overlap your strokes to avoid spaces between them.

Step 7. Keep a large piece of clean cheesecloth in your free hand. Dab any mistakes—say a glob of paint suddenly runs off the brush—lightly with the cheesecloth while the surface is still wet.

Step 8. Work quickly. If the phone rings, let it; if your child comes to the door, ignore him. Glazing over a large surface can be done because a damp surface and a lot of water in the glaze staves off drying for a little while, but don't tempt fate. Once you've started working, don't stop for anything. Egg tempera *does* dry fast.

Step 9. If paint begins to drip, take the panel off the easel and put it on the floor. This will settle the paint where it is.

Step 10. Let the glaze dry before applying more paint. This usually takes several minutes, but on a rainy day count on as long as a half hour. When it's dry put it back on the easel.

Step 11. One final word of advice: try not to glaze under artificial light. Some glazes, like yellow ochre, are hard to see.

Scumbling. As I mentioned earlier, scumbling can be part of either the underpainting or the overpainting. I generally finish a painting with a glaze, but occasionally I'll scumble, as I did in *Pulse* and *The Spider* where the light curtains set the tone of the pictures.

For a translucent scumble, mix your colors with medium and a lot of white thinned with a little water. Semi-transparent scumbles are applied with the same scrubbing action that semi-opaque scumbles are, so don't use your best brush. Instead get out one that has grown old and battered with use. Then load up the brush with a lot of color and really scrub it around.

Combinations

For the sake of clarity, I've made it sound as if underpainting and overpainting are two distinct steps. They can be, but in my case, they aren't. I can't tell where underpainting stops and overpainting begins. Because tempera paint is seldom opaque you can, for example, glaze, paint over the glaze with a semi-opaque color, glaze again, and then scumble. All the colors will come through to some degree. So instead of talking in terms of underpainting and overpainting, a better idea might be to think about painting layers of transparent, translucent, and semi-opaque paint.

It's hard to visualize the effects of painting transparent colors over semi-opaque colors and the reverse until you try them. And the best way to experiment with these color combinations is to practice putting different ones together without any thought to composition. So keep a small panel around just for that purpose. Test out several combinations, then scrape them out with a razor blade and try some more.

Figure 14. Here is an example of scumbling. On the left side I used fairly opaque paint, while on the right it's more transparent.

Butterfly Net, *26″ x 38″. Scratching with the tip of a razor blade can create a basic grass texture. Here I underpainted first with a light green, let the paint dry for several days, and applied a coat of darker green. Then I scratched with a razor blade down to the light green color. Collection, Mrs. S. A. Weintraub.*

9. Painting Textures

By now I hope it's clear that egg tempera possesses a whole range of possibilities that aren't usually associated with the medium. You've had a taste of its remarkable ability to produce a fantastic variety of effects by painting with transparent, translucent, and semi-opaque colors. So far, however, I've limited this explanation to painting with conventional brush strokes. But there are many other methods of applying paint—methods that are generally considered part of the underpainting, but are occasionally thinned down with water and used as part of the overpainting. Their function is to create textures.

Texture means different things to different people. To some people the word connotes a painting surface. An oil painter, for example, may create a rough texture on canvas by building up thick impasto, or he may keep his paint fairly thin and allow the rough texture of the canvas to show through. Artists working on paper or panels may also utilize these surfaces to produce interesting textures.

When I refer to texture, however, I'm speaking of the texture of the object I paint—a rock, a piece of cloth, a cement wall. Although the textures of the actual objects are rough, you can't simulate this tactile, three-dimensional quality with egg tempera. Textures must remain two-dimensional. But egg tempera can create the illusion of texture; paint can be applied in different, unconventional ways that make smooth surfaces look chipped or fuzzy or pitted. Here are my methods for achieving these ends.

Splattering

In the last chapter I suggested various ways to underpaint: a layer of strong color, a layer of opaque white, a layer of color in opposition to the initial wash. Each of these layers could also be splattered on. Don't misunderstand me. I don't mean that you should splatter on the whole underpainting. Underpainting consisting solely of splattering (or any other unconventional device) would be insubstantial and monotonous. But one or more applications does wonders when you're trying to paint walls, pavements, or rocks. The surfaces resulting from splattering look grainier, or more pitted, than surfaces painted with regular brushstrokes.

Step 1. The first thing to do when you decide to splatter is to turn all your other paintings to the wall. Next, take off your shoes if you don't want to ruin them or wear old battered, paint-covered ones. Splattering is a messy process.

Step 2. Put the panel on the floor. You can splatter a panel on the easel but paint has a tendency to run down the surface.

Step 3. If you want to splatter only part of the panel, cover the rest with newspapers or a mask (more about masks later in this chapter). If you're looking for an overall tonality as I do, you probably won't need to protect any areas of the painting during the first stages of underpainting. But as you begin to build up forms, you may want to cover them before you splatter. Or if you're planning to paint a sky, as I did in *Gull Rock*, you wouldn't want the texture of the sky to be affected by the textures used in the rest of the painting.

Step 4. Mix up a puddle of color with a lot of medium and a lot of water. You might try a mixture of bold colors—reds, blues, greens—and a more opaque mixture later, or vice versa. There are no strict rules about the colors you can use for splattering. I would advise, however, that you avoid splattering tones that are much darker or lighter in value than the shades underneath. This principle, which I first mentioned

Figure 15 A. Here's how I splatter. In this picture the brush is to one side and is about to hit my hand.

Figure 15 B. The brush hits my hand and splatters the paint, which strikes the panel in horizontal ovals.

when I discussed glazing, holds true for almost all the techniques described here. The reason is that the juxtaposition of such subtle color differences helps give egg tempera painting an overall glowing quality. But this rule isn't unbreakable.

Step 5. With a loaded brush in your right hand (if you're right-handed), stand over the panel. Then tap the wide part of the ferrule of a housepainter's brush against the palm of your left hand which is held vertically to the panel. Direct the paint onto the area you want splattered. Drops of paint will arrive on the panel in the shape of horizontal ovals. Remember that the drops of splattered paint shouldn't be so thick that they stand up from the surface. If they do, they'll crack off. Applied properly, you'll scarcely be able to feel them if you run your fingers across the splatters.

Step 6. Don't splatter the whole surface with the same amount of paint. Even distribution is monotonous. Strive instead for areas with a little texture and areas with more texture.

Step 7. If you want your splattering to be blurred, splatter first light tones and then dark tones while they're both still wet. The colors will blend together. And if you plan to repeat this step, make sure you vary the colors a little each time to produce contrasts.

Step 8. Any splattered areas or even individual drops you don't like you can wipe out with cheesecloth. You get unhappy accidents with this method as well as happy ones, so be prepared to eliminate the mistakes before they dry. You don't have to rush because the surface should be fairly wet. But if the phone rings while you're working, don't answer it; the paint will set before you return.

Step 9. Leave the panel on the floor until it dries. If you prop it up, the paint will run down.

Step 10. Later, rework the splatters if you want. If your drops are dark you might want to put a few small highlights around their edges. This will give the illusion of light falling on the rim of a small crevice or hole. If the splatters are light you might put shadows under them to make them look like pock-marked pebbles or stones.

Dripping

Splattering and dripping accomplish similar results. The only difference between the two is that drippings fall directly down on the panel to form round circles instead of horizontal ovals. I prefer splattering to dripping because it does a better job of putting objects in perspective. Splatters have direction, drips don't. Splatters produce a feeling of movement which creates a three-dimensional quality; drips tend to remain flat and two-dimensional. Still, I use them occasionally for surfaces seen head-on, such as the wall in *The Pigeon*. But for surfaces viewed from an angle, such as the pavement in *Chalk Flowers*, splatters are better.

The dripping procedure is basically the same as splattering except for the position of the hands. Instead of keeping your hands vertical to the panel, hold them horizontally. Then tap the wide part of the ferrule of the brush in your right hand against the palm of your left. Tap hard enough to knock paint off the brush, but not so violently that it comes off in great big drops.

You can also drip by squeezing paint out of the bristles with your hand. This method will make large drops, however, and should be used sparingly.

Stippling

Stippling can be used with either semi-opaque or transparent colors, so you could say it functions as either underpainting or overpainting. In *The Corner Seat*, for example, I stippled where I could have glazed. I had underpainted the sweater with a warm greenish brown color, and planned to cover it with a transparent ultramarine blue glaze. Since the sweater was to be rough in texture, however, I decided to stipple, rather than paint the blue in. Conventional brushstrokes can't produce the textures stippling can because stippling allows underpainting to show through better. Even smoother materials such as the nuns' robes in *Crossings* benefit by stippling. Here's how you use this technique.

Step 1. Mix up a puddle of color (again only one value darker or lighter than the underpainting) with lots of medium and water.

Figure 16 **A.** *I'm preparing to drip paint by raising my brush above my left hand.*

Figure 16 **B.** *As the brush hits my hand paint will fall onto the panel (which is out of sight). The drops will resemble round spots.*

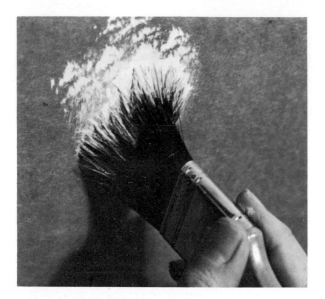

Figure 17. With quick up-and-down dabs, I stipple paint on with an old housepainter's brush.

Figure 18 A and B. Examples of stippling. The first represents a lighter color stippled over darker paint, while the second shows the results or stippling on a dark color. Stippling can be used in either underpainting or overpainting.

Figure 19. Here I've sponged a light color over a darker one. I frequently use a sponge to create clouds.

Figure 20. A light color was drybrushed over a dark one on the left and the procedure reversed on the right. Drybrushing is good for creating wood textures and blendings.

Figure 21. A toothbrush is a secondary tool, but you can create interesting effects by pulling your finger across a brush that has been dipped in paint.

Figure 22. Here's an example of paint scratched off with a razor blade. It aids in creating such textures as hair, grass, and wood.

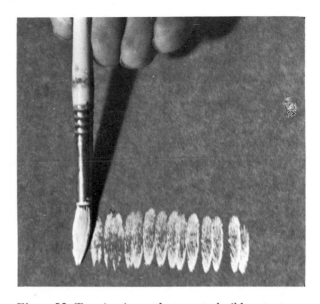

Figure 23. Tapping is another way to build up texture. Take the side of your brush and quickly tap it against the panel.

Figure 24. This shows paint applied quite thinly with a palette knife.

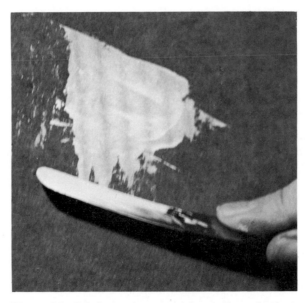

Figure 25. Putting paint on with a palette knife is similar to spreading butter on bread.

Figure 26. Here paint has been dabbed on with a cheesecloth.

Step 2. Use a housepainter's brush. Each hair leaves a dot of color on the panel so you'll want a brush that will distribute paint evenly, unless uneven distribution is your goal. The bristles of nylon brushes and commercial stipplers cling together, preventing the individual hairs from leaving their mark.

Step 3. If you plan to stipple a small area, cover the rest of the painting with a mask.

Step 4. Stipple with short up and down motions, keeping the brush perpendicular to the panel. The more you stipple, the smoother the surface will look as more and more dots of color crowd together. So if you want a rough-looking texture, like a fuzzy sweater, don't overdo. If you want a smooth texture, like the material in the nuns' robes, stipple the area several times with fairly wet paint.

Step 5. Stipple in the whole area at once. It will look smoother than if you do one part first and then come back to do another. The joints, or the overlapping of dots where the old section meets the new, will be noticeable.

Sponging

A very thick commercial sponge is one of my most valuable tools. The underpainting in *Baskerville Rock*, for example, was done largely with a sponge. Sponging usually works better when you use a lighter, more opaque color over a darker underpainting. A sponge coated with a color darker than the underpainting isn't bad for roughing up a texture, but the sponge excels at effects in white or light colors. In any event, try to create as many effects as you can. The possibilities are endless. Even when the sponge is almost out of paint you can still get interesting results.

To experiment with a sponge, first round off one end with scissors, leaving the other edge straight. Next, wet the sponge thoroughly with water, squeeze it out, dip it in the paint, and dab on the panel. Try the rounded edge with very wet paint for blurred effects such as clouds; the straight edge with fairly dry paint for, say, an old board.

Blotting

No matter what technique you're using—splattering, sponging, etc.—the results can be changed by blotting with cheesecloth in quick little dabs. Cheesecloth doesn't absorb all the paint; it re-distributes some of it, giving it a blurred quality. And if you want an implement that absorbs even less paint while spreading it around more, use the edge of your hand.

Toothbrush

I seldom use this tool, but it can be effective for, say, producing tiny flecks of dust (see *Through the Window*). Simply dip the brush into the paint, pull your finger across the top of the brush and splatter paint onto the panel.

Drybrush

This isn't a description of a brush, but a technique, and a most useful one for egg tempera painters. First load your brush—usually one that's past its prime—with a lot of paint. Then wipe most of it off on a cloth, or the back of your left hand if you are right-handed. Leave just enough on so that when you drag it across the panel some paint will come off. Your strokes will be broken and irregular because there's not much paint on the brush.

Drybrush is great for textures like stone and wood. You could, for example, drybrush on a dark color, scratch it with the edgt of a razor blade, drybrush again, (this time with a lighter color), and then glaze. The result is a silvery wood-like finish like the floor in *Wooden Horses*. Drybrushing is also good for blending. If you need a little shadow under the eye or nostril and want the edge to be blurred, then drybrush.

Scraping

Razor blades can also create certain textural effects. Using the tip of the blade you can scratch out paint to create wood textures. Or you can use the point of a single-edge blade to indicate strands of hair or blades of grass, for example.

To work properly, however, your panel should be covered

with a thoroughly dry (weeks, if possible) underpainting. If the underpainting is still soft, the razor blade will scratch out the paint, leaving the gesso panel exposed. Furthermore, the layer of paint you plan to scrape off must be a different color or tone than the one underneath. Scraping down to a similar color would prove very little. For example, if you want to define strands of blond hair, the layer of paint beneath the dark color you scrape out should be light.

Tapping

The object of tapping is to build up texture. As you tap and pull the brush away, you deposit infinitesimal points of paint on the panel with the brush, creating a rough texture.

To tap, load paint (I usually use a light color over a darker one) on a medium-sized sable brush and wipe most of it off, as you do when you drybrush. Don't use a good brush that comes to a point because you work with the side of it. Then, holding the brush nearly parallel to the surface, quickly tap the side of the brush against the panel.

Pebble-like Strokes

To preserve the textures produced by unconventional methods, I frequently paint over them with many tiny little unconnected strokes. This allows the texture to come through the gaps. The strokes remind me of pebbles laid horizontally on a surface. In other words they go from right to left. So if you're right-handed, pull the brush from left to right to make smooth strokes. If you push from right to left, the bristles will fan out, making irregular strokes.

Palette Knife

The use of this tool will send a shiver through anyone who has studied the classic egg tempera technique. Everyone knows that oil painters use a knife to put paint on thickly— a technique that's verboten for the egg tempera painter. But with practice you can learn to wield a knife so you can apply tempera in thin layers. Once you do you'll be able to achieve

Figure 27. A collection of masks. The flower in the middle was used in The Monument.

Figure 28. Cut-outs from masks. Not only do I use these "negatives" in other paintings, but I'm thinking of painting a still life of them as they hang on my studio wall.

wonderful textures. I find it particularly useful in applying highlights on skin.

Use the palette knife this way: scoop up a small, thick amount of paint with your palette knife and scrape it off onto the panel in the desired area (see *Birdman*'s hands and face). The action is similar to buttering bread. And if you see, before the paint has dried, that you applied it too thickly, take it off as you would if you put too much butter on a piece of toast.

Miscellaneous Techniques

Almost all of these methods for producing textural effects are controllable. I know pretty well what results I can get from splattering, dripping, etc. But here are a few techniques that I can't control:

Cheesecloth, Tissue, and Rags. Dip the material into your puddle of paint, soaking it completely. Place it on the panel and pat it down. The longer you leave it on, the more solid the effect. Then pull it off. You might like the effect or hate it—there's no way of knowing. I sometimes employ this method to simulate the texture of an old wall.

Glass. Cover a pane of glass with paint, press it down hard on the panel (lying on a flat surface) and pull the pane of glass away quickly. Again the results are unpredictable, but it's fun to play around with these devices.

Masks

Throughout this chapter I've talked about protecting areas from random splashes of paint by masking them off. Masks can be simple affairs, or elaborate ones. I've made some so elaborate that I've spent the whole day cutting them out. Take, for example, the flowers in *Chalk Flowers*. Once I'd finished underpainting the pavement, I drew the flowers on heavy paper and cut them out. Then I attached the mask to the panel with drafting tape and stippled in the flowers through the holes.

The cut-outs from these masks can also come in handy. So when you make a mask, don't throw away the part you cut out—you might want to use it again. For example, suppose I wanted to glaze the pavement in *Chalk Flowers* with another color, but not the flowers. I could attach the cut-outs to the flowers and then glaze with impunity. Or I might find a use for them in another painting where I planned to use flowers in the background.

Acetate

For a very elaborate design, such as the rug in *The Parakeet*, a mask is out of the question. Working out such a complex plan would drive a person crazy. Instead I painted the design on acetate which was clinging to the panel by static electricity. Then I taped the top to the panel, lifted up the acetate, and painted underneath.

Refining Textures

All the above techniques and strokes require refinement before I consider a painting finished. Crude, unconnected splatters and strokes, for example, need blending; bold colors require glazing and scumbling before I get the tone I'm looking for. So now I get out my sable brushes to smooth the details with thousands upon thousands of conventional little brush strokes. This process takes time—more time, perhaps, than all the other techniques I've described put together. But it's worth it when I'm rewarded with a painting glowing and shimmering with inner light as only an egg tempera painting can. Just how I do it I'll explain in the demonstrations at the end of the book, as well as show you how I actually use the techniques I've just described.

Under the Elm, 18″ x 24″. The rock texture was produced by first sponging on a middle tone and then splattering with darker tones. After the overall texture was completed, I delineated the individual rocks. Collection, Mr. and Mrs. Herbert W. Marache, Jr.

Octopus (Above), 22″ x 36″. Skies can be achieved by either stippling a light color over a dark one or vice versa. In this painting I chose the former method. Courtesy, Midtown Galleries.

Autumn Landscape (Right), 24″ x 36″. Here I stippled a dark color over a light one to create the texture of the sky. Stippling dark over light is more difficult than the reverse because it requires much more blending. Notice the Octopus in the background. Collection, Ranger Fund Purchase, National Academy of Design, New York.

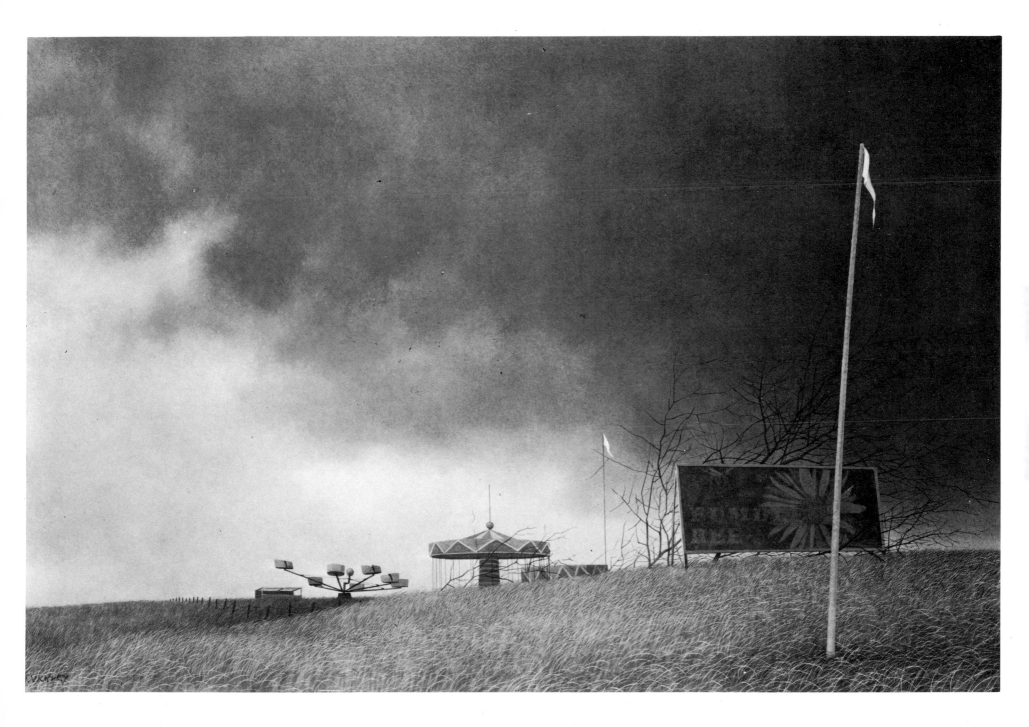

Chrissie, 23″ x 30″. After I'd worked a month on this picture, I realized that the only good thing in it was the left eye. So I scraped out the entire painting, except for the eye, and started over. Collection, Mr. Robert Clary.

10. Corrections

I was taught never to make corrections in egg tempera because I was told I wouldn't have to. My detailed drawing was supposed to take care of that—it was my insurance policy against error.

That's all fine and good. But what happens if you discover a glaring fault in composition after you begin to paint on the panel? It's too late to go back. The India ink drawing for all practical purposes is on for good.

My method keeps a painting fluid because you can correct mistakes at any time. Say you've worked out a fairly good design in your head or on paper, and although part of it isn't quite right, you're dying to get started on the panel. You can. You don't have to worry about every compositional or color detail in advance. If a color combination doesn't work out on the panel, wash it off; if a figure doesn't look right, scrape it out with a razor blade. And you can correct big areas as well as small. Let me give you a rather extreme example of a major correction.

Some years ago I began a painting of an old woman. After working on it for a month, I decided that the only good thing in the whole painting was the left eye. This was a pretty drastic situation and called for some real soul-searching. I didn't want to destroy the painting; I'd already spent a lot of time on it. On the other hand, I knew it was no good. Finally I scraped out the entire panel except for the eye and started over.

It goes against human nature to admit defeat, but I force myself to re-think a painting, or a part of a painting, that I recognize as esthetically unsatisfactory and to redirect my efforts. And egg tempera is a natural medium for such revisionary tactics because corrections are so easy. Here's how you go about them.

Water

Suppose you realize within seconds that your strokes are no good. Wipe them out with a piece of damp cheesecloth. You can do this easily if you keep a piece of clean cheesecloth nearby or, better yet, in your free hand, especially during the early stages of a painting.

Or suppose you decide you don't like the initial wash you applied, but you don't want to waste the panel. Wash it off. You can do this whether the panel is wet or dry—just use a little more elbow grease as you scrub the dried wash with your wet cheesecloth.

Water can also remove a layer of paint several hours old, provided the underpainting has dried for several days. Dab with a piece of wet cheesecloth or a large brush, and then wash the entire surface. Only the last layer will come off unless you rub so strenuously that you work off the underpainting too.

Razor Blades

Ninety percent of all my corrections are done with razor blades. I can "erase" big areas and small; many layers or just one; overpainting and underpainting.

The only time scraping becomes a bit tricky is if you want to correct an area of paint that adjoins paint you don't want touched. But there's no real problem here either. All you have to do is mask off the finished area with drafting tape. Now, here's how you scrape:

Single-edge Blades. If you want to correct a mistake by going back to the gesso panel and starting over, use a single-edge blade. Hold the blade at an angle of nearly 90 degrees and scrape with the whole edge.

Figure 29. When I make a mistake, I scrape paint off with a razor blade.

Figure 30. I decided the hand should be closer to the body and the fingers more tense, so I scraped the hand out with a razor blade and then sanded to give the gesso some tooth.

Figure 31. After laying in a wash, I redrew the hand with a brush. Now the fingers grip the edge of the chair.

Figure 32. I refined the hand with glazes and began to blend in the background.

If the mistake is so small that you can't scrape with the flat edge, you can use the points of the blade. First sandpaper the point until it's slightly rounded. Then scrape very lightly and very carefully. The point can nick the panel and damage the gesso. If you do make a deep groove with the point, smooth the area out by using a fine grade of sandpaper. But try to avoid such accidents by using the point only when absolutely necessary.

Double-edge Blades. If you want to take off a top layer of paint that has dried for several days and covers paint that has dried for weeks, use a double-edge blade. Such a blade is far more flexible than a single-edge one, and performs this delicate operation more easily. First, tape one edge to avoid cutting yourself, and then scratch the layer out very gently. But remember, make this correction *only* if the painting underneath has had a chance to dry for weeks or, better still, months. You'll scratch the underpainting in any case, but it won't come off if it's well dried.

Sandpaper

Initial corrections can be made by sanding with coarse sandpaper instead of scraping, but sanding takes longer and paint clogs the sandpaper quickly. So I use sandpaper as the second step in the correction process. I scrape out most of the paint with a single-edge blade and then finish up with sandpaper. Sanding is great for getting right up to the edge of drafting tape masks and allowing you to remove paint you can't get to with the flat of a blade. When you try this, cut the sandpaper into small pieces—you could almost say finger-sized pieces. Then work the sandpaper into the inaccessible areas by manipulating it with your index finger.

Sanding is essential even if you're not attempting correc-

tions of this sort. After you scrape out paint with a razor blade, the gesso has a porcelain-smooth surface. This surface must be roughened up before paint will adhere well, so sand the area with a fine grade of sandpaper.

Repainting

Washing, scraping, and sanding down to the panel means rebuilding form from scratch, but that's better than being stuck with a mistake. And the rebuilding process isn't difficult. It would be if you were using local color, that is a single color, but not if overall tonality is your goal. Local color demands exact matching; tonality doesn't require that kind of precision. What you're looking for is an interesting combination of colors that add up to an overall effect, not a perfect match. Here are two examples of what I mean:

Underpainting. Suppose you've painted a figure and you don't like the position of the hand. Scrape the area down with a razor blade until the gleaming white panel appears, then sandpaper. When you're ready to correct your mistake, apply an initial wash and coats of underpainting that approximate the colors you used before. It doesn't matter that they aren't exactly the same. The point is that each layer modifies the next so that you're gradually building toward something. You don't have to hit it on the nose the first time. You can work up to it.

Glazing. Apply the final glazes the same way. To approximate the color of the hand with the other flesh tones, experiment on the panel by glazing up one shade and then down a shade until you reach the effect you want. This might take a little time, but you don't have to worry about paint buildup or muddy colors with egg tempera. So you can glaze indefinitely.

Figure 33. The hand has been completely corrected, and the background and sleeve carried further.

Figure 34. These are some of my frames. Notice how heavy they are and how far out they'll jut from a panel. These characteristics help protect paintings.

11. Care of Egg Tempera Paintings

Before going into methods of preserving egg tempera paintings, I'd like to say a word about the durability of the medium. Egg tempera in the long run is as tough and permanent —if not more so—than oil.

Still, it's subject to three kinds of damage, and each occurs at a different time. First, if the paint is going to crack or fall off the picture for any reason (if it's applied too thickly or whatever) it will do so within a few days or weeks.

Second, egg tempera scratches easily within the first few years. As I said before, tempera dries to the touch within seconds, but the chemical process takes at least a year. So I treat my paintings with extra care during this time. I don't lean other paintings up against a new one. I watch my fingernails when I handle a picture. I ask my wife to be careful when she dusts—one thoughtless jab with the spine of a feather duster can mean a nasty scratch. Once the paint dries, however, the surface toughens. And for some reason this process seems to go on for some years. A painting ten years old, for example, will resist scratches better than one two years old.

An old cliché describes the third kind of damage. "Oil cracks, while egg tempera crackles." A "crackle" resembles a tiny spider web and usually occurs after hundreds of years. You can tell the difference between cracks and crackles by comparing damaged Renaissance egg tempera and oil paintings. A crack in, say, a Titian might cover a large area and be visible across a room. A crackle in an old tempera painting would be almost unnoticeable until you got up close. This is fortunate because crackles are inevitable over the centuries —and irrepairable. But in any case it's nothing the painter has to worry about in his lifetime.

Varnishing

Many people varnish egg tempera paintings to protect them. I'm against this procedure. Varnish destroys the subtle sheen of egg tempera and replaces it with a hard glossy shine. And, since sheen is one of the medium's loveliest characteristics, if it's eliminated, you've eliminated one of the reasons for using the medium.

Varnishing also changes the values of a painting. The dark and medium values become much darker while the light values stay approximately the same. The result? The subtle juxtaposition of values that is so beautifully achieved with egg tempera is lost and the painting looks "jumpy." Again, why use the medium if its inherent qualities are undermined?

Another reason why I dislike varnish is that it precludes repairs and changes. Frequently, after I've "finished" a painting, I see a way to improve it several years later. But it's too late if the painting has been varnished. Painting in tempera over varnish is like painting in watercolors on a pane of glass —the paint not only crawls, it slides off.

You can, of course, repair a varnished painting by using oils, because you can paint oil over varnish. But this won't solve the problem over the long haul. As time passes, oil paint and egg tempera paint darken at different rates. So the corrected area will look different over the years than the rest of the painting, and it will be obvious that two mediums had been used.

One last word about varnishes. Modern chemistry has improved them somewhat. You can now spray on acrylic varnishes which don't change the values as much as the older varieties do. But repairs are equally impossible.

Waxing

Waxing is another protective device. Again I advise against it because changes and repairs are out of the question. Furthermore, you have to watch out never to let sunlight shine on a waxed painting. It will melt or get sticky like asphalt on a hot summer day.

Coping with Mold

Mold, or "bloom," is occasionally a problem with egg tempera. I have a moldy painting in my studio right now, but I'm sure I could have prevented its present sad state. I tucked it away in a dark corner for years because I didn't like it. If I had hung it on the wall it might not have molded.

But sometimes you can't stop mold. Humid climates encourage egg tempera to mold, and certain pigments like cadmium yellow have a tendency toward blooming. Don't get me wrong, though. Molding is the exception, not the rule, even in humid areas. But if one of your paintings starts to bloom, try cleaning it with a little acetic acid and water. This should do the trick.

Mold is another reason why varnishing, in my book, is unwise. If you varnish a painting and later discover mold, you've locked it in. The only way to get rid of it is to remove the varnish and then thoroughly scour the mold off. And to top it off, varnish itself can mold.

Polishing

When I finish a painting I look at it from an angle to see if I notice any disparity in sheen due to slight differences in the medium formula. If I do—and I usually don't—I polish, or burnish, the dull areas with a clean, dry cloth. What I'm doing, in essence, is rubbing off miniscule amounts of paint. Polishing should be done with care, however. It can be dangerous; you can polish down to an underpainting you don't want revealed.

Repairing

Exhibitions are hell on egg tempera paintings when they're new. Before and after they are hung they're apt to get bumped or nicked. The frame of one gets knocked into the panel of another when stacked. No matter how carefully gallery or museum employees handle my paintings they scratch them occasionally. If I varnished or waxed my work, I wouldn't have this problem so often, but I'd rather repair a picture and have it look just the way I want than destroy the beauty of egg tempera.

Fortunately, most repairs are easily made. If a large spot is damaged, I just scrape out the whole area with a razor blade and sandpaper it. Then I proceed as I would if I were correcting.

Matching colors exactly is trickier. Most egg tempera colors dry darker than they appear in either dry or paste form. But not always. I've noticed that certain dark colors, like dark blue, tend to dry slightly lighter. So test them out on an old panel before you go ahead.

Removing Foreign Matter

Dirt, hair from a brush, or other foreign matter can be brushed off the surface of the panel. They don't become embedded in paint as they do in an oil painting. Oils are sticky, whereas egg tempera is not. So as paint dries, remove particles from the panel with cheesecloth or a brush. Hair from a sable brush and small particles present no problem, but a hair from a large housepainter's brush will leave a mark which will require a little touching up.

Cleaning

Dusting is the best way to keep paintings clean. If something stronger is indicated, however, try water. I'd never use soap for fear it would leave a film behind, but I wouldn't hesitate to go over a picture with a piece of wet cheesecloth. Let me explain how effective water can be by telling a true shaggy dog story.

One day after I'd just completed one of my best paintings, I heard our dog whining at my studio door. He always whines when he wants to come in so, out of habit, I opened the door. He was a bloody mess from a dog fight. Before I could

stop him, he ran in and shook himself violently in front of my painting.

It was a catastrophe—there was blood all over the panel. I knew I only had a few seconds to do something. I rushed into the kitchen, put the painting flat on the table, threw a lot of water on it and dabbed with cheesecloth. It worked— the blood came off. True, the top layers I'd recently been working on were damaged and had to be repaired, but the dry layers underneath, which were weeks to months old, were hardly touched.

An interesting sidelight to the story came up a few days later when I was talking to my insurance man. He said that if it had been a human who bloodied my painting, I could have submitted a claim. But I wasn't covered for animal damage!

Framing

Everybody has his own preference in frames, but I like a heavy frame that juts far out from the panel. Such a frame offers considerable protection to the surface of the painting, particularly when it's sent to exhibitions. Any other kind is potentially dangerous. For example, a friend of mine insists on a flat frame that thrusts a painting forward. He finds this esthetically pleasing, and I can't quarrel on that point, but each time his paintings return from an exhibition they're damaged. This is one case where I'd sacrifice esthetics for the well-being of my work.

Glass

Some people cover egg tempera paintings with glass as a protective measure. I don't like regular glass because of the reflections it creates, and I don't approve of non-glare glass. Non-glare glass must touch the painting to work properly, but nothing should press up against the surface of an egg tempera painting. If the picture is moved or jarred, even slightly, the glass will rub the paint.

Cradling

Attaching strips of wood to the back of a panel to prevent warping is called *cradling*. Many painters feel this is a necessary precaution and build cradles for their panels before they paint on them. I don't for the simple reason that I never know how big my picture will be until it's almost done. I often start on a 36″ x 48″ panel, but it may end up half or a fourth of that size. Even when the painting is completed, I don't cradle unless I see that the panel is warping. If this happens I put the painting on an old sheet on the floor, cut strips of 2″ x ¾″ wood to the dimensions of the picture, and glue them to the back of the panel around the edges.

This is a very simple cradle and most authors recommend more elaborate ones with many cross-strips. If you're interested in such a cradle, a good artist's handbook or manual will tell you how to make one.

Shipping

Special care should be used when you ship paintings. I place a piece of plywood, the size of the framed picture, on the top of the painting so that it rests on the frame. This cover shields the painting without pressing against it.

Some painters I know label their paintings with instructions for their care. I haven't done this as yet, but it's probably a good idea. Some instructions I'd include are: don't let your friends or children rub their fingers on it; don't place it in direct sunlight or a dark place; and avoid touching it with a sharp object.

Demonstrations

Chalk Flowers, 20" x 28". Petals and branches were cut out of tracing paper and attached to the panel. I then stippled the panel a lighter color through the holes. Collection, Mr. and Mrs. S. Lewis Hutcheson.

Demonstration 1. The Birdman

Earlier I mentioned that ideas for paintings sometimes come to the surface like deeply embedded splinters slowly working their way out. *The Birdman* is a perfect example of this process.

About fifteen years before the painting was begun, I saw a man whose hands and face fascinated me. I thought he'd make a marvelous model for some paintings I had in mind of clowns so I asked him to pose. After completing several pictures, I planned one more and made a detailed drawing of his hands and face, clothing him in a vague but fantastic costume. Then for one reason or another, I never got around to the painting.

With the passage of time, his hawk-like face and talon-like hands haunted me, however, and many years later I began toying with the idea of using the drawing as the basis for an entirely different type of picture. The concept wasn't completely clear, but I knew I wanted to stress his hawk-like appearance.

To emphasize this characteristic I decided to surround him with stuffed birds. One bird would appear pompous and cocky; the second a little silly; and the third dangerous and menacing; each was to represent a facet of his personality. I've no idea what the original model was really like, of course; this was simply my imagination at work.

I made a few rough sketches of this image. None were very good, but I decided to plunge ahead anyway and see what would happen. When I began to paint, I realized that everything depended on how successfully I could create the figure. If I couldn't capture the hawk-like characteristics— the tense, aggressive, powerful qualities—of the man, I knew I wouldn't be able to go on with the picture.

1. Detailed Drawing. This is the India ink drawing I did of the model fifteen years ago. I knew I'd never see him again so I made the drawing a finished work.

2. Preliminary Lay-in. Since I wasn't quite sure of the final composition, I picked a 3 x 4 foot panel and planned to position the figure in such a way that I would have plenty of room on all four sides. As I started to work, I toned the panel slightly with a wash of ochre and a little viridian green. Then I mixed several puddles of light colors and underpainted with different combinations of these colors. When I'd finished, nearly every color on my palette had found its way onto the panel. Next, I drew in the body with a brush in neutral grays, established the shadows with a bluish gray, and scrubbed in off-white highlights on the neck and shoulder with an old sable brush. Then I mixed up some warm gray and tapped paint on the body with an old No. 5 sable brush to build up a slightly rough texture.

 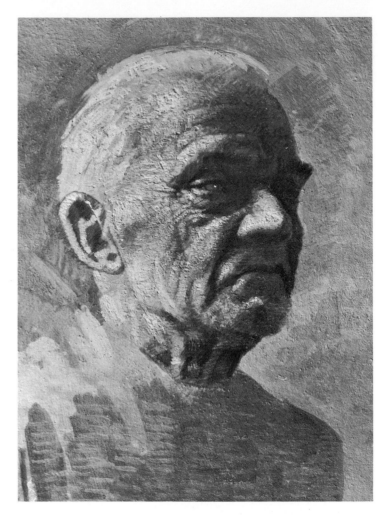

3. Close-up of Head. *Next I worked on the head. I underpainted the lines of the face and the deepest shadows with dark bluish gray. Flesh tones were applied and highlights brought out with pure white. I scumbled in the hair with an off-white and the area around the profile with a light warm gray.*

4. Another Close-up. *This photograph is exactly the same as the preceding one except that it was taken in violently raking sunlight. I shot the painting in this way to show how I brought out the highlights around the eyes and other areas with a palette knife. When I use my knife for this purpose I use drier paint than usual. I dip my knife into paste mixed with medium that has been sitting for a few minutes while some of the water dries out. The result is a less buttery paint that stays in place when applied. If it were wetter, it would tend to smear.*

5. A Closer Shot. This photograph shows my strokes in greater detail.

6. *Close-up of Hands.* The hands were painted in the same way as the face: shadows put in with dark bluish gray, flesh tones applied, and highlights pulled out.

7. *Another Detail of Hands.* Again, this is the same stage as the preceding one, except for the raking sunlight. The highlights which I'd dabbed on with my knife look thick—almost like impasto. But if you were to run your finger over the panel, you could scarcely feel the strokes. I painted the cuff by loading a fairly large, but battered, sable brush with a slightly dirty white. I like to let my palette get a little dirty—and by that I mean I let my colors mix slightly—so no color will be pure. In most cases, my whites contain a little ochre or blue.

8. Preliminary Bird Drawings. I knew I wanted a large bird—an eagle, perhaps—to hover over the man in a threatening way. Never having painted birds before, however, I wasn't sure of their anatomy. I went to the Museum of Natural History in New York City and took photographs of stuffed birds. I searched through books and magazines for other pictures. Nowhere did I find exactly what I wanted. Working from the photographs I already had, I made several drawings on acetate with watercolor. Here are three of them.

9. Design Experiments. I continued to work on the bird and finally produced this version. At the same time, I drew a tree stump on another piece of acetate and placed both on the panel. Then, turning the painting to the wall, I left it for a few days. When I returned I realized I liked the way the stump acted as a counterpoint to the elbow. Other related angles formed by the wings and arms were also shaping up nicely. So I lifted up the acetate and roughly painted in the bird and the stump with burnt umber and viridian green.

10. Underpainting. Before I could underpaint, I needed a mask. I drew the shape of the figure on tracing paper, making the tracing paper mask about half an inch smaller than the figure all the way around. Then I carefully made the edges with drafting tape cut to shape with scissors and attached it to the panel. Placing the panel on the floor, I began a series of paint applications. First I loaded up a large housepainter's brush with ochre, burnt umber, and viridian. I then stippled paint around the panel, working dark paint in at the bottom where I knew light would not fall. Next I loaded a smaller brush with a thin version of the same mixture and splattered it across the panel. I repeated this action in certain areas with very thin but pure cobalt blue. The area around the head of the man was stippled with a color resembling a flesh tone, and other colors were sponged on in different areas.

11. Removal of Mask. A few minutes later, after the paint had dried, I began to peel off the mask, dramatically revealing the untouched figure underneath. Although I'd nearly obliterated the panel by stippling, splattering, and sponging, you can still see the silhouette of the strongly painted bird underneath.

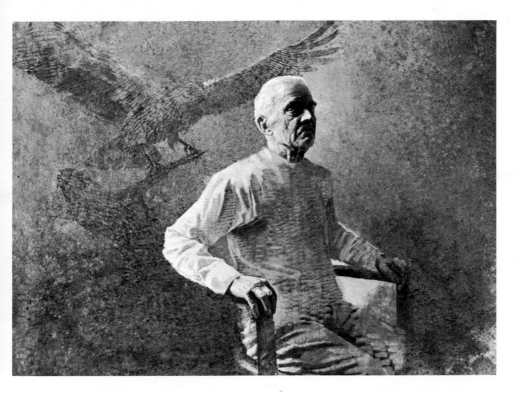

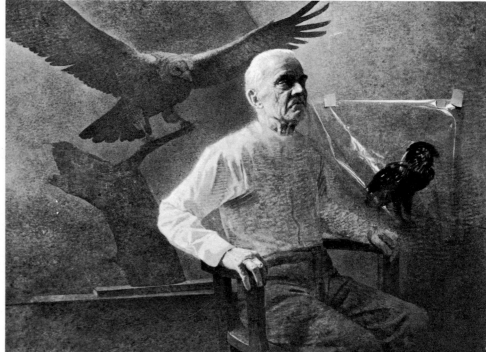

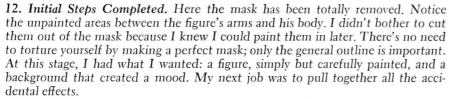

12. *Initial Steps Completed.* Here the mask has been totally removed. Notice the unpainted areas between the figure's arms and his body. I didn't bother to cut them out of the mask because I knew I could paint them in later. There's no need to torture yourself by making a perfect mask; only the general outline is important. At this stage, I had what I wanted: a figure, simply but carefully painted, and a background that created a mood. My next job was to pull together all the accidental effects.

13. *Second Bird Introduced.* I spent several days painting out the unpleasant accidents and refining the happy ones. Then I restated the bird and darkened and strengthened the form of the stump. I also began to indicate the chest in the background and the architecture of the room. The low ceiling and slanted wall give the room an oppressive atmosphere. I also drew the cocky, hawk-like bird on acetate and moved it around until it seemed right. I wanted the bird to look as if it were almost sitting on the man's arm, creating the illusion of a falconer.

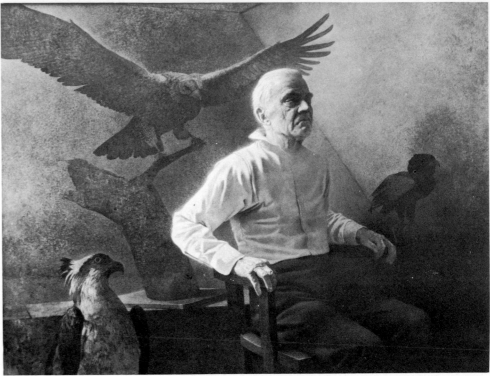

14. *Close-up of Bird.* As you can see, the bird is still quite rough, but the splattering and stippling that cover the entire body suggest feathers. I had painted in the head but somehow it just wasn't right; it didn't really look like an eagle so I began to search for more photographs.

15. *Third Bird Completed.* I painted the hawk-like bird a viridian green tone, brought some tree branches into the studio to study the bark, and repainted the base of the stump which had been badly thought out. The third, rather funny-looking bird has also arrived on the panel at this stage via the drawing-on-acetate route. The shirt and pants were done in quite some detail. I started to add a collar meant to resemble the ruff of a bird and scumbled the entire shirt with medium gray over the tapping strokes. The tops of wrinkles in the shadows were pulled out by drybrushing with warm gray. Shadows and creases of the shirt were glazed with a transparent darker gray, while the shadow areas of the pants were glazed with a darker brown.

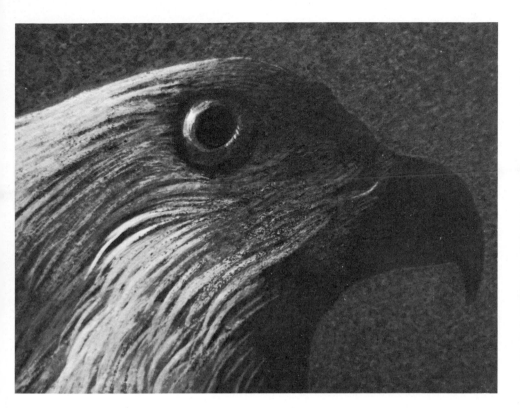

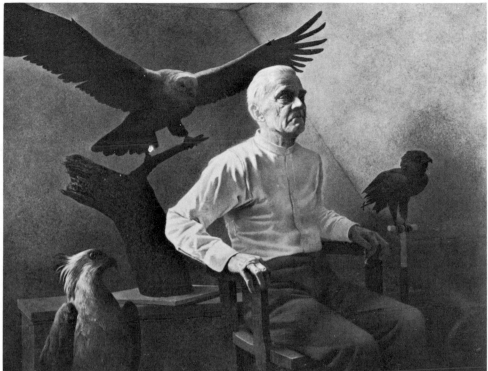

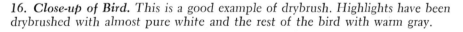

16. *Close-up of Bird.* This is a good example of drybrush. Highlights have been drybrushed with almost pure white and the rest of the bird with warm gray.

17. *Finishing Touches.* The original collar, which I intended to look like a bird's ruff, didn't work out, so I changed it to a simpler style. All sorts of other parallels, however, are obvious: the claws of the three birds and the man's hands; the jagged edges of the birds' feathers and the hair on the back of the man's head; the texture of the bark and feathers; the angles of the eagle's wings; the stump and the man's arms. And before completing the picture (which can be seen in color on page 87) I gave the figure corduroy pants to echo somewhat the feathers of the bird on the left side.

Demonstration 2. Baskerville Rock

Somewhere in my travels I came across a huge boulder left over from the ice age. It interested me because it rather resembled a large skull; the pits seemed to form nostrils, the crevices, lips. The resemblance wasn't striking, but it gave me an idea. Why not change the contours of the rock so they subtly hinted at a great dog, perhaps the hound of the Baskervilles? Whether or not anyone else notices this play on words is immaterial. What does count is that the resemblance gave me an idea to start with.

I also wanted to suggest a surfer on top of the rock, daring the unknown astride the head. But the figure is incidental. The rock is the important element in the picture, and I knew that if I didn't get the texture of the rock right, the painting would fail.

1. Preliminary Steps. *After toning the panel with an ochre glaze I began to under-paint. First, I dipped a sponge into a puddle of titanium white and dabbed over the wash until something like a rock texture appeared. Then I loaded a bristle brush (yes, I do occasionally use them) with a mixture of colors and tapped the side of the brush in various areas. Loading a housepainter's brush with warm pinks and yellows I scumbled paint into other areas. Then I put the panel on the floor and splattered it slightly with pure yellow ochre. With a large brush I painted thin coats of red, yellow, and blue again in different places. Finally I splattered again with off-white. The whole time I worked, I covered and uncovered areas of the panel with newspaper so the entire rock wouldn't receive the same colors.*

2. Close-up of the Rock. *Notice the splatters throughout the painting and the light sponge marks on the right side. The dark area on the left is a glaze. Once I'd finished the underpainting I took a small brush and painted in the cracks and crevices until a general skull-like shape emerged.*

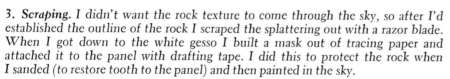

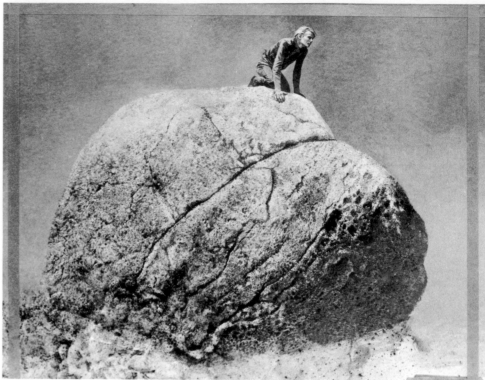

3. *Scraping.* I didn't want the rock texture to come through the sky, so after I'd established the outline of the rock I scraped the splattering out with a razor blade. When I got down to the white gesso I built a mask out of tracing paper and attached it to the panel with drafting tape. I did this to protect the rock when I sanded (to restore tooth to the panel) and then painted in the sky.

4. *Sky Painted.* The sky has been roughly painted with a large brush and tapped with a smaller one. At this point I started to establish the edges of the picture. Drafting tape helps define the possible edges but doesn't commit you to these boundaries. In this case, in fact, I later expanded them.

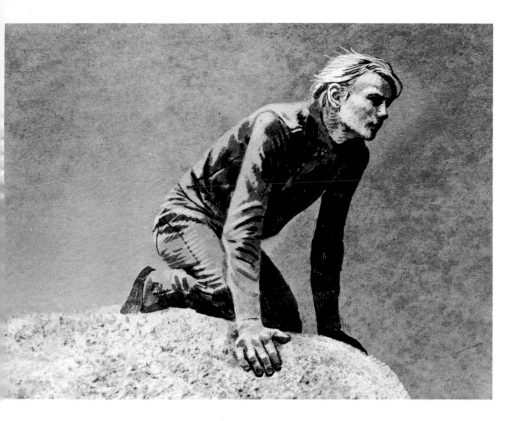

5. Close-up of Figure. The figure was roughly painted in neutral tones (ochre, green, and burnt umber) which add up to a warm brownish gray. Highlights and shadows have been established. Notice the use of the sponge on the rock.

6. Further Elements Introduced. The curves of Baskerville rock had to be counterbalanced by other curves. Otherwise the large rock would seem to roll off the right side of the panel. So I put in a rock in the left-hand corner, and another in the lower right-hand corner and dabbed both rocks with a sponge.

7. Small-Scale Splattering. Here's a variation on the toothbrush technique. After I finished sponging paint on the two rock areas I masked off the entire painting except for the rock on the left side. Then I dipped a brush in thin paint and pulled the bristle back with my fingers. As the bristles sprang back into place they splattered tiny dots of paint onto the panel. I repeated the operation on the portion of the rock in the right-hand corner that is exposed to the sunlight.

8. Refining Textures. This shows a close-up of the rock. All along I've been refining the texture of the rock with a small sable brush. I eliminated textural effects that were wrong and took advantage of those which worked. And I've drawn in lines that create the rhythms I want. Some of these lines and spots suggest faces or facial features, but I haven't tried to exaggerate them. At this stage I still have weeks to go before I achieve the final texture I want.

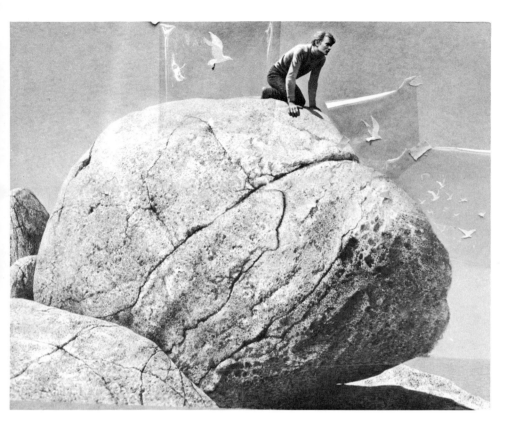

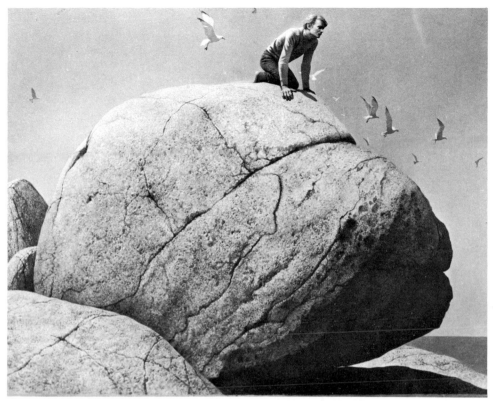

9. Elaboration of Design. I knew there would be sea gulls in the painting so I had to finish the sky before I could paint them. I took the mask I'd previously built for the rock, made one for the figure, and attached them to the panel. Then I mixed up a color tending toward blue with a lot of ochre. With a large house-painter's brush, I stippled in the blue, creating barely visible feathery clouds. When I finished, I stippled the sky near the horizon one tone lighter. After I removed the masks, I worked over the sky for two or three days, blending, darkening, and cleaning up the edges where the sea meets the sky. Then I added more rocks on the left side because I felt the design needed still more balance. I painted birds on bits of acetate and arranged them in various ways.

10. Final Overpainting. When I was satisfied with the position of the gulls, I painted them a neutral tone, pulling out highlights and glazing down shadow areas under wings. Next, I worked on the shadow under the rock. I wanted it to look dark and mysterious, so I glazed it down with a lot of burnt umber, viridian, ochre, and blue. The glaze was very dark but it didn't obliterate the texture underneath. With the exception of a few minor details, the painting is nearly done. All it really needs now is a few more sea gulls. (See completed painting on page 86.)

Demonstration 3. Under the Seesaws

Painting doesn't always come easily to me. I may have a germ of an idea, but developing it into a completed work of art can take longer than getting a design for a space craft off the drawing boards and onto the moon. *Under the Seesaws* is just such a case in point. I began to think about this painting many years ago, and as this book goes to press, it's still unfinished.

The original idea for the painting came from a movie I made called *Playground*. In the movie there's a scene in which children ride seesaws up and down, creating and re-creating shadows. After watching the film strip I made a sketch of the scene on toned paper. The sketch was badly organized, cluttered, and physically impossible as far as the shadows went. I don't insist that every element in a painting be accurately depicted, but I do think such things as angles and shadows ought to at least look reasonable. Still, I liked the idea and after I'd reworked the sketch several more times on tracing paper, the shapes and rhythms began to emerge the way I wanted them to.

At this point, although I hadn't satisfactorily solved the design problems, I started to paint on a panel. But it didn't take long to realize that my problems were insurmountable, so I scraped the whole thing off.

From then on I returned to my sketches about once a year for five or six years. I even went so far as to build a small model seesaw. This experiment solved some problems but wasn't completely successful.

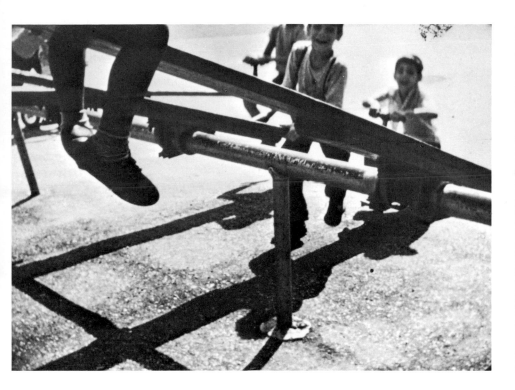

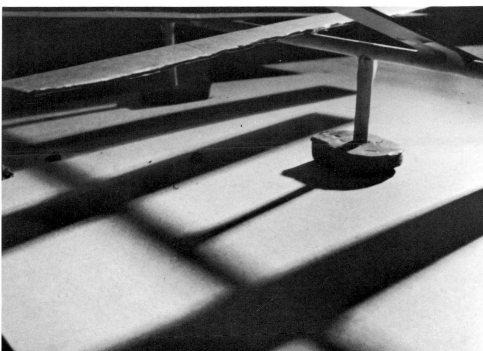

1. *Film Clip.* Here is a frame from the movie that gave me my original idea. Notice how different the scene is from the one that I finally designed.

2. *Cardboard Model.* One of the few props I've ever built, this cardboard seesaw is about two feet long.

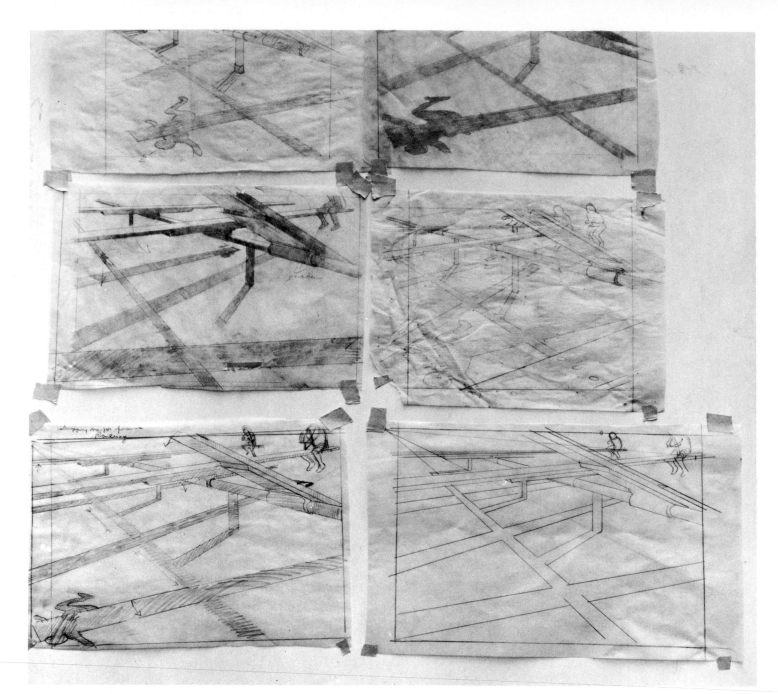

3. Preliminary Designs. Two or three years later I looked at my sketches again. They weren't as bad as I'd thought, and I made a few more. After I'd drawn the sketch in the lower right-hand corner I felt I could start another painting. I transferred the sketch onto the panel by scribbling on a second piece of tracing paper, placing it between the panel and the drawing, and going over the outline of the sketch with a pencil.

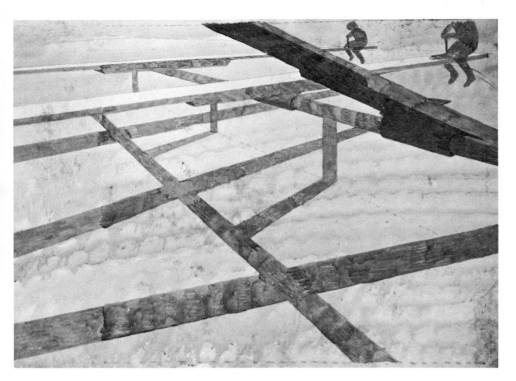

4. Preliminary Wash and Underpainting. After transferring the drawing, I washed the whole panel with yellow ochre, not quite obliterating the pencil drawing. Next I painted the shadows, the seesaws, and the figures with a transparent mixture of ochre and burnt umber. The edges of the painting are indicated, but I haven't really decided on the size of the picture.

5. Textures Created. Placing the panel on the floor and loading up my house-painter's brush with burnt umber and ochre, I splattered paint across the surface of the panel. I repeated this process with thin viridian green and then thin cobalt blue. After these dark splatters had dried, I mixed up puddles of light paint—off-white containing reds and yellows—and splattered them on.

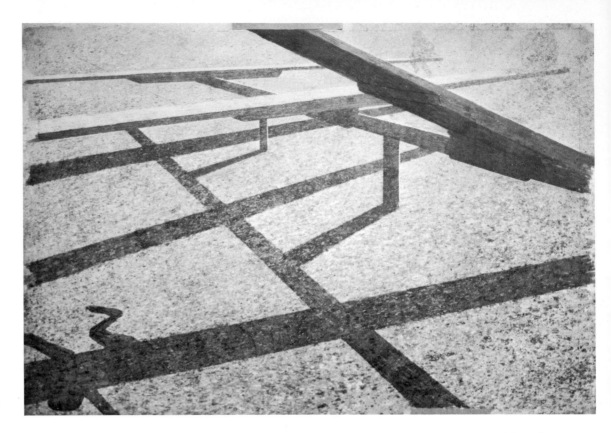

6. *Close-up of Textures.* Notice the horizontally shaped ovals of paint caused by splattering. These ovals catch the light from the right and give the painting a shimmering jewellike quality. At the same time they resemble crushed pebbles in asphalt.

7. *Glazing.* I redefined my forms and shadows with glazes, allowing the textures created by splattering to come through. The splatters on the seesaws themselves, however, are undesirable. So I scraped them out with a razor blade and sandpaper and repainted the shapes with a neutral tone containing ochre, cadmium yellow, and cadmium red light.

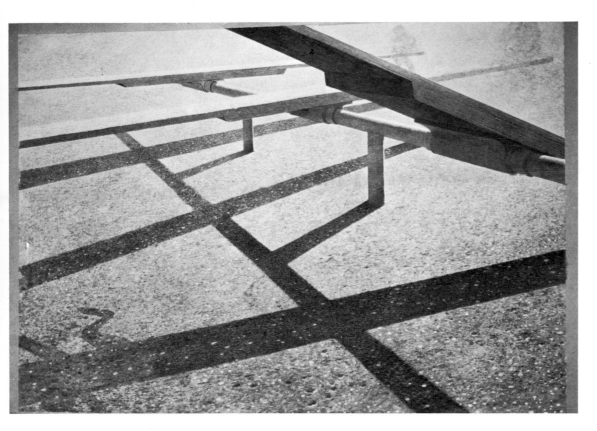

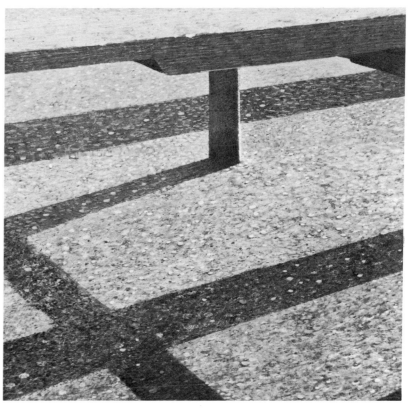

8. Boundaries Established. *Here I've darkened the lower left-hand corner where the least light will fall and clarified the compositional lines of the painting with further applications of underpainting and glazes. The edges of the painting were also established with drafting tape.*

9. Stippling. *I refined the texture of the ground by painting out splatters I didn't like with a small sable brush and painting in thousands of pebbles by hand. I made a mask for the seesaws and the pipes and then stippled in more paint. The texture of the ground is about one-third done at this stage. Compare this close-up with the earlier one in this series.*

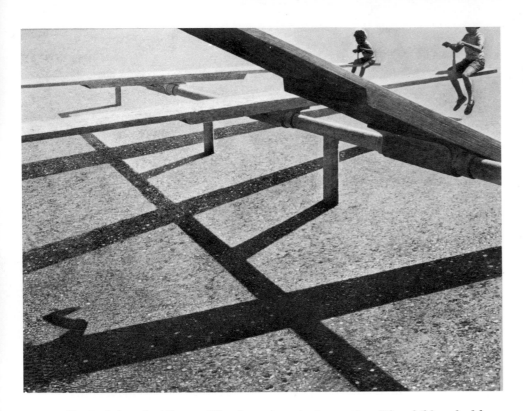

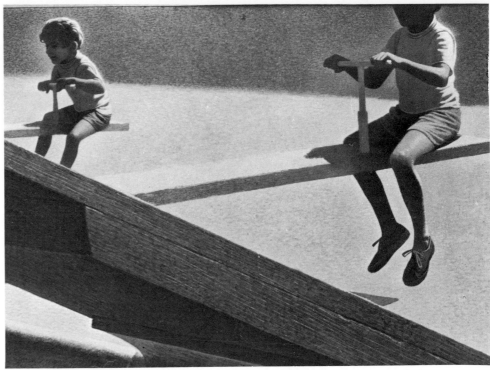

10. Refining the Figures. The figures required attention. The children had been carefully painted in a neutral tone of ochre and umber, but I didn't know what glazes to use for their clothes. To help me choose, I painted several colors on pieces of acetate and placed them over the bodies. The shadow in the left-hand corner has been partially reworked, but it needs further study.

11. Shadow Added. I decided the figures were getting lost at the top of the painting, so I added the shadow of a building. Then I accentuated the figures by scumbling in a halo of light around their heads and shoulders. I also worked on the wood texture of the seesaws by scratching them with a razor blade. The scratches will require several glazes before the texture is completed.

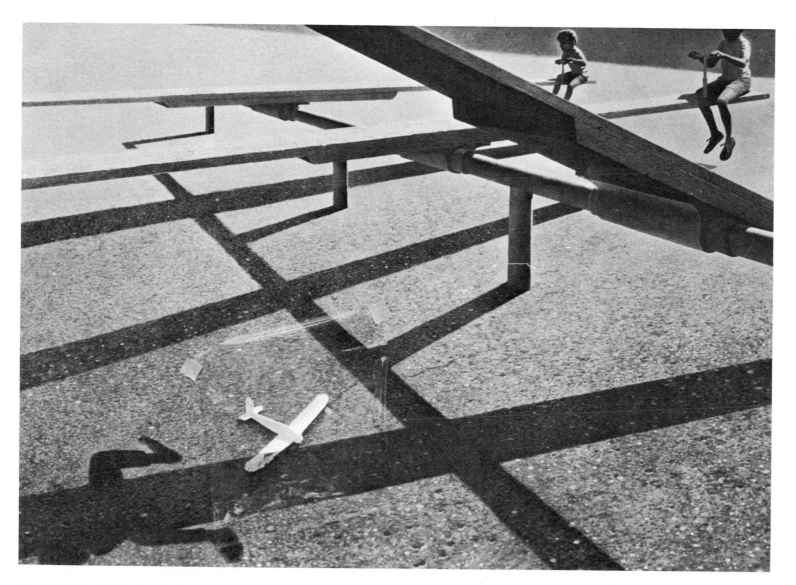

12. Unfinished Painting. Earlier, I decided that I'd use a motif I've employed before in my paintings—a glider. I had two reasons for doing this: to balance the composition, and to accentuate the narrative element of the painting. The children seem to be riding the seesaws like gliders; they are airborne, free from the earth. I used my old trick of painting on acetate to decide where to put the glider. Right now it has landed near the shadow of the figure on the left, which as you can see has been repositioned for the second time. The painting, after many years of work, still needs much more. I'm dissatisfied with the upper left-hand corner; I may put in some more seesaws up there. I may also put in a couple of cats to play with the glider—it would add additional balance to the design. But I don't know—I'll have to wait and see.

Demonstration 4. Plastic Umbrella

Reflections on wet streets have long fascinated me. Puddles can reflect whole landscapes or only parts of them, like trees or clouds. Drying pavement breaks up these images and distorts the landscape. The abstract quality that results challenges me with its possibilities.

When the plastic umbrella was developed these possibilities multiplied. I found I could paint the texture of wet pavement, whole reflections, fragmented reflections, solid figures, distorted figures seen through umbrellas, and reflections on the plastic.

I introduced nearly all of these elements into *Plastic Umbrella*. This painting was done in cool, greenish tones to project the feeling of wetness.

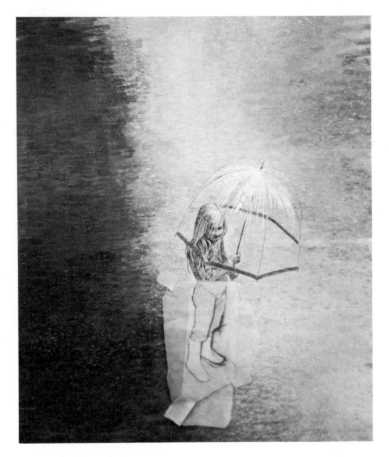

1. Preliminary Steps. As usual I washed the panel with an ochre tone. Then I roughly applied a darker glaze to the left side, which represents the shadow of a tree, and scumbled in a lot of pure white in the center and cool gray on the right side. The figure was crudely drawn, but because I didn't like the lower body I redrew it on tracing paper.

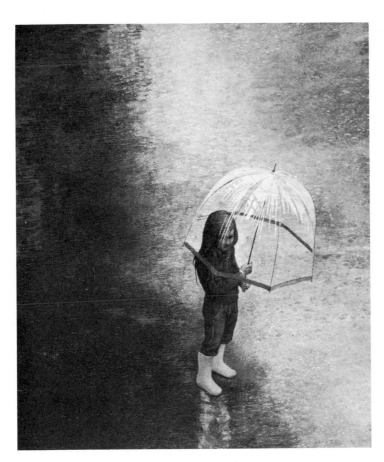

2. Splattering. Removing the tracing paper, I painted in the legs and reflections. I covered the reflection of the tree with newspaper and the figure with a mask, and then splattered in some light and dark tones. When they dried I put the picture in a frame, seemingly establishing the dimensions. Later, however, I cut the picture so it no longer fit the frame.

3. Detail of Pavement. A close-up of the painting after splattering. Notice the light and dark ovals caused by directing paint horizontally across the panel.

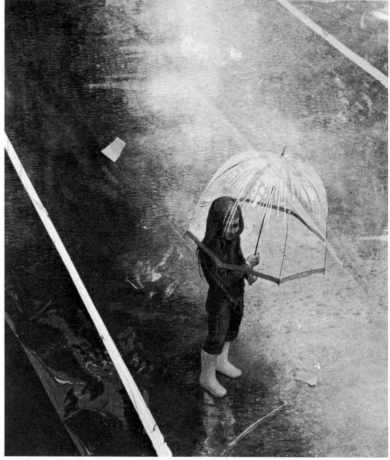

4. Painting the Figure. This photograph was greatly magnified (the head is really about an inch-and-a-half high) to show how I put in color. First, I laid in a neutral tone for the figure, pulled out highlights with opaque paint, and glazed down dark areas. Then I started to define the silhouette by scumbling in an off-white tone around it. Rhythms of the hair were worked out with a small sable brush. In large paintings I frequently pull out highlights on the hair and face with a palette knife, but this painting was too small. To get an idea of how small it is, look at the brushstrokes on the umbrella. Although they look uneven here, the real brushstrokes don't; the jagged edges aren't visible to the naked eye.

5. Establishing Perspective. Lines help to place a figure in space. When the whole background of a painting is a reflection, it's difficult to see what the figure is walking on. So I drew lines on pieces of acetate and attached them to the painting with tape.

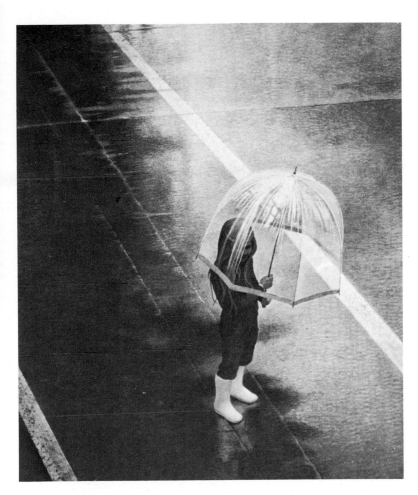

6. Re-arranging. Just as I was about to paint the lines in, I decided I didn't like their position. Instead, I wanted a line to bisect the umbrella (one of my favorite compositional devices is to bisect curves with lines). To echo the white lines I painted in thin expansion joints on the street. At this stage I was also defining the puddles more and tapping on light tones in the lighter areas.

7. Brushstrokes. Notice the irregular strokes throughout this close-up. Such strokes allow the paint underneath to come through and sparkle.

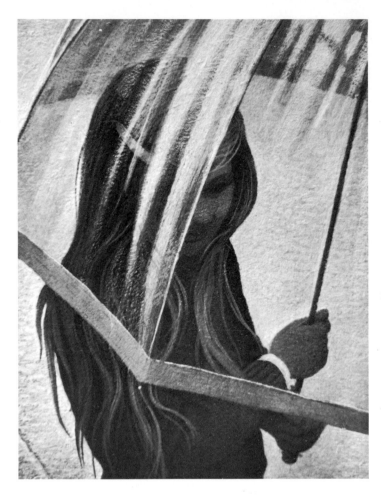

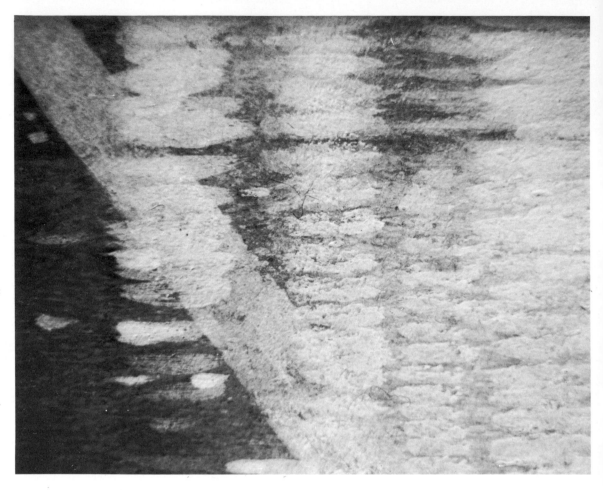

8. **Drybrush.** *Another close-up of the painting. The hair has been further developed and the reflections on the umbrella drybrushed on. Before I drybrushed here, I loaded up a small brush with off-white, wiped most of it off on a rag, and even more on the back of my hand. Then I dragged the brush across the panel.*

9. **Tapping.** *A close-up of my tapping strokes. I tapped, then glazed with green and ochre, and tapped some more. I repeated these steps a dozen or so times before the pavement satisfied me. If you look closely, you can see several hairs caught in the paint. The rather strenuous tapping stroke caused them to break off the brush. Right after the photo was taken I flicked them off with my finger.*

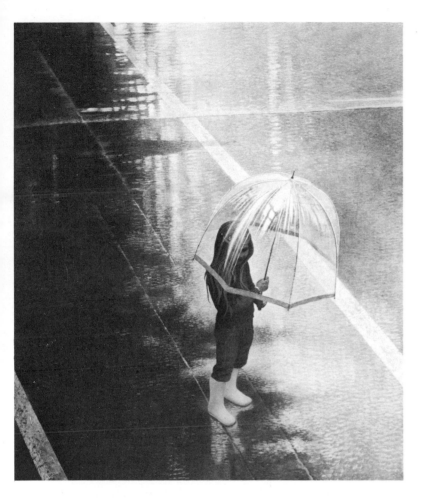

10. Scumbling and Further Tapping. Here I've emphasized the white reflection by tapping and scumbling further. The outline of the tree reflection has also been clarified and the line on the left glazed with green and umber. The final painting (see page 72) has approximately an inch cut off the two sides.

11. Additions. Leaves were also added before I finished the picture. In this close-up you can see them as they were before completion. They've been painted lighter than they'll eventually be, and require glazing down. You can also see the jewellike quality of the tapping strokes which range in color from rather dark to pure white. These strokes, like the leaves, were also glazed darker.

Demonstration 5. Golden Gliders

Light is a particular preoccupation of mine and it's an outgrowth of a study of Turner. In his work, which anticipates Impressionism, the real world loses all solidity and density. My forms are much more solid and realistic, but the luminescence of the backgrounds of my paintings frequently resembles the quality of light found in Turner's paintings. *Golden Gliders*, a painting done in warm red and yellow tones, is an example of what I mean.

If the object of *Plastic Umbrella* was to portray cool wet reflections, my aim in *Golden Gliders* was just the opposite. I wanted to show heat reflections on asphalt; I wanted this to be the hottest picture I ever did. The result is a shimmering, glowing scene bathed in hot afternoon sunlight.

1. Underpainting. I began with an ochre wash and then decided that no matter how hot the picture was to be, I needed some cool areas in the underpainting. So I painted the right side with cool, dark bluish grays. The light areas were covered with tapping strokes in reds and yellows.

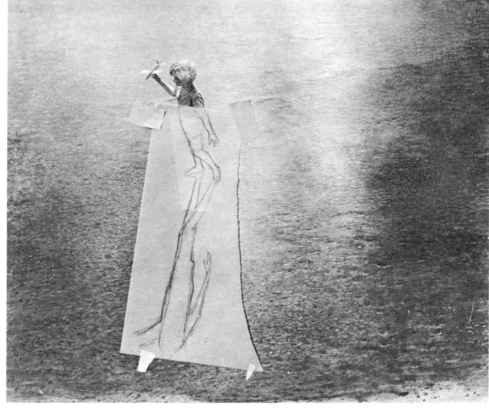

2. More Underpainting. The surface of the panel has now received several applications of paint to build up texture. Almost every inch was tapped with a tone one value darker or lighter than the underpainting. The middle of the panel was scumbled with off-white and light yellow. Pinks and reds were painted both transparently and opaquely. A mixture of white, red, and yellow was splattered on the light areas—the dark areas covered with newspaper—and harmonies created by additional splatters of darker tones of burnt umber and green. With a brush I indicated incipient potholes and ripples in the hot asphalt.

3. Tracing Paper Drawing. I underpainted the figure with a warm, monochrome gray. The only things I did well were the head, shoulder, and one arm, so I redrew the rest, plus a shadow, on tracing paper. (I use tracing at times instead of acetate because you can draw on it in more detail.) After I made my drawing I placed a piece of white paper between the tracing paper and the panel so I could see the outline better.

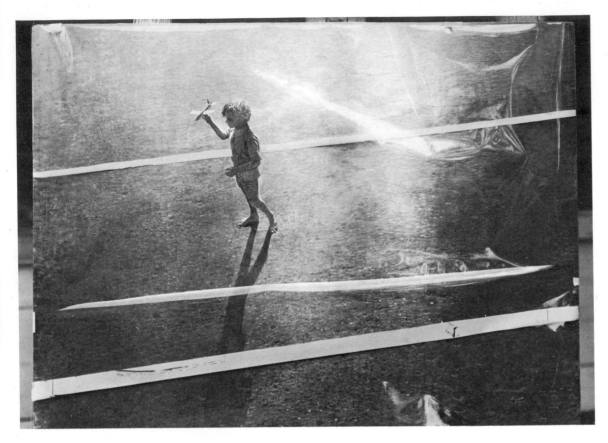

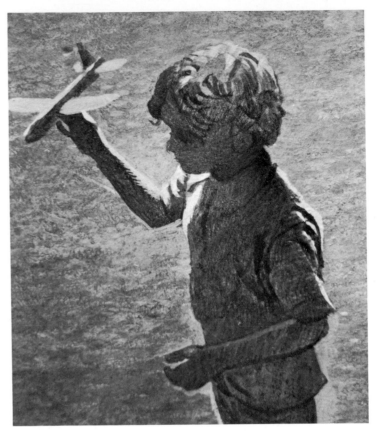

4. *Perspective.* The drawing was transferred onto the panel, but the position of the right arm still didn't suit me and I changed it again. To establish the figure in space I decided to use the device of street lines. The lines also create horizontal movement. Like a jet stream from the plane the child is holding, the lines force the viewer's eye to move. As usual I painted the lines on acetate and moved them around (the middle line in the photograph is a reflection from a piece of acetate). When I was satisfied, I masked the pavement off with drafting tape and stippled the lines with a bristle brush and thick opaque paint. Tape makes the lines too straight if put on evenly, so when applying it I move it back and forth to create tiny bulges.

5. *The Figure.* The close-up shows how free painting can be. There's no need for the kind of tight drawing advocated by traditional egg tempera painters. I painted the whole figure with a minimum of loose strokes, following my usual pattern: underpainting with neutral tones, pulling out highlights, and glazing dark areas.

6. Stippling. Here is a close-up of the effects created by stippling. I used a bristle brush to create the irregular quality of paint worn off the white lines through wear. Notice also how I painted light rims around dark splatters to make the spots look like pits.

7. Refinement. This painting went out to all edges of the panel except the bottom. At this stage I've refined the details of the asphalt, added little stones, and built up reflections by tapping. The painting needs more planes and thousands of tiny little strokes of transparent color before truly beautiful, shimmering light results. (The completed painting appears in color on page 73.)

12. Some Final Thoughts

Egg tempera is like a haunted house. People are afraid of it because they've heard so many stories about it, not because these tales are based on fact. I think the reason for this is that many of those who write about and teach egg tempera aren't really painters. They see themselves more as high priests guarding and perpetuating an ancient religion rather than practicing a workable art technique.

So let's get some things straight. Certain chemical properties of egg tempera prevent you from exploring the whole gamut of painterly devices. Impasto, for example, is out of the question because paint won't adhere permanently when applied thickly. But, by and large, egg tempera is nearly as versatile as any other medium. You can paint large, you can paint small. You can paint in the field, or in your studio. You can make mistakes, create marvelous textures, produce beautiful luminosities. You can do almost anything you want. Furthermore, the medium doesn't require a degree in chemistry or the patience of Job.

But it does require an open mind—a mind willing to experiment. I've told you of my experiments. Splattering, glazing, diving right in without preliminary sketches, are techniques I've found through the years work for me. But don't accept them as the final word. In fact, I advise you to try some of the methods of the old masters. As you may have gathered, I'm an impatient man at times. But you may be perfectly suited to cross-hatching, or love doing numerous drawings. Some of the most gorgeous paintings of all time were created by these painstaking devices.

My aim in this book has been to emphasize the idea that there are many ways to use egg tempera, not just one. And with a lot of practice and some imagination you should be able to come up with techniques I've never even thought of. But you'll never know unless you try.

Bird in Flight, 31" x 45". The illusion of flight and pursuit are created here. The shadow resembles a bird pursued, perhaps by a hunter; the nails could be bullets and the electrical connection, a rifle. The abandoned lighthouse seen in Coast Guard Station provided the background. Collection, Mrs. Louisa Carpenter.

Index

Edited by Jennifer Place
Designed by James Craig and Robert Fillie
Composed in 10 point Electra